Alaska
Wild

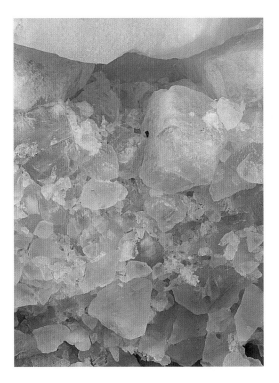

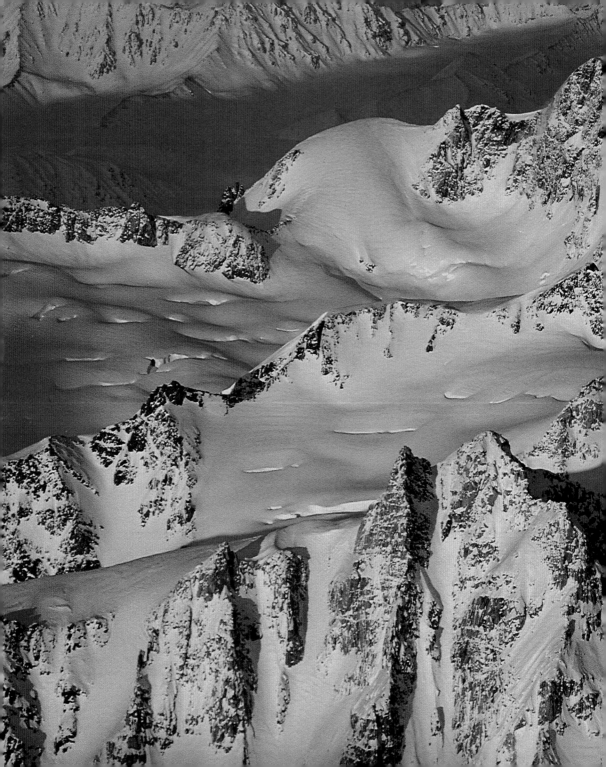

Alaska
Wild

Celebrating Our Natural Heritage

ART WOLFE

SASQUATCH BOOKS
SEATTLE

For Alaskans and Alaskans at heart

Photographs ©2004 by Art Wolfe

Printed in Hong Kong
Published by Sasquatch Books
Distributed by Publishers Group West
11 10 09 08 07 06 05 04 6 5 4 3 2 1

Book design: Kate Basart
Interior layout: Stewart A. Williams

Frontispiece: Glacial ice, Lamplugh Glacier, Glacier Bay National Park and Preserve
Title page photo: Aerial, Saint Elias Mountains, Wrangell-Saint Elias National Park and Preserve

Library of Congress Cataloging-in-Publication Data is available.

ISBN 1-57061-423-7

Sasquatch Books
119 South Main Street, Suite 400
Seattle, WA 98104
(206) 467-4300
www.sasquatchbooks.com
custserv@sasquatchbooks.com

{ introduction }

A laska is often called "the last frontier," and with good reason. This is one of the few places left in the world where you can see and experience the land as nature created it: wild, primal, and untouched by humans. From the tall Sitka spruce trees in the Southeast's temperate rain forests and the rugged coastlines of Prince William Sound, to the hundreds of wind-swept islands in the Aleutian chain and the vast mountains of the Interior, Alaska is truly a land of immense natural diversity. Volcanoes and glaciers still rule the landscape, rare and abundant wildlife roam freely across borderless tundra, oceans teem with whales and sea lions, and eagles are as common here as ravens.

Yet what is most impressive is that eighty percent of Alaska's land remains public land. The forty-ninth state contains two national forests, sixteen national wildlife refuges, fifteen national parks, and countless state parks—all protected for visitors to enjoy. And, thanks to a network of dedicated naturalists, there are also countless ways for you to learn and experience these places. Programs and information celebrating Alaska's unique history, people, habitats, and environment are designed to share with visitors the issues affecting our nation's last great wilderness and underscore the importance of stewardship.

Those who work for Alaska's public lands strive to connect both visitors and residents to the region's cultural and natural heritage. Only through that connection can we ensure that wild places like Alaska will be around for the next generations to enjoy.

Go and discover *Alaska Wild*.

Moira B. Paddock, Director of Operations
Alaska Natural History Association (ANHA)

ANHA is a non-profit partner of Alaska's parks, forest, refuges, and other public lands, supporting educational programs through publishing and operation of educational bookstores.

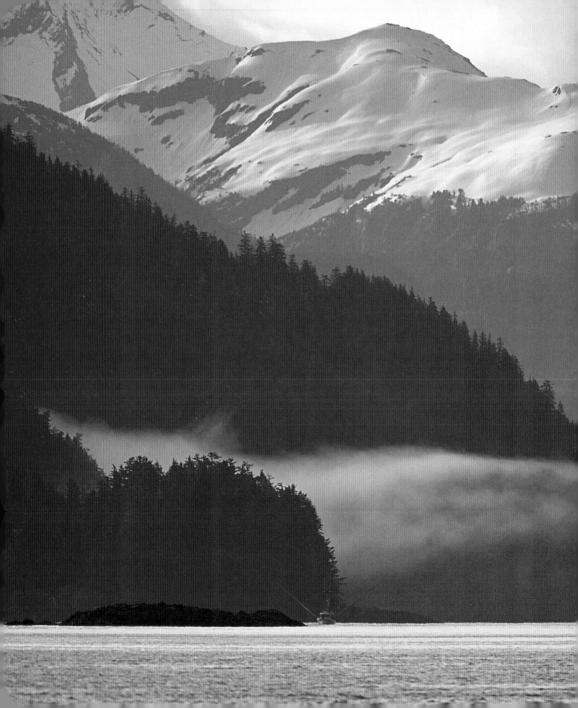

{ southeast }

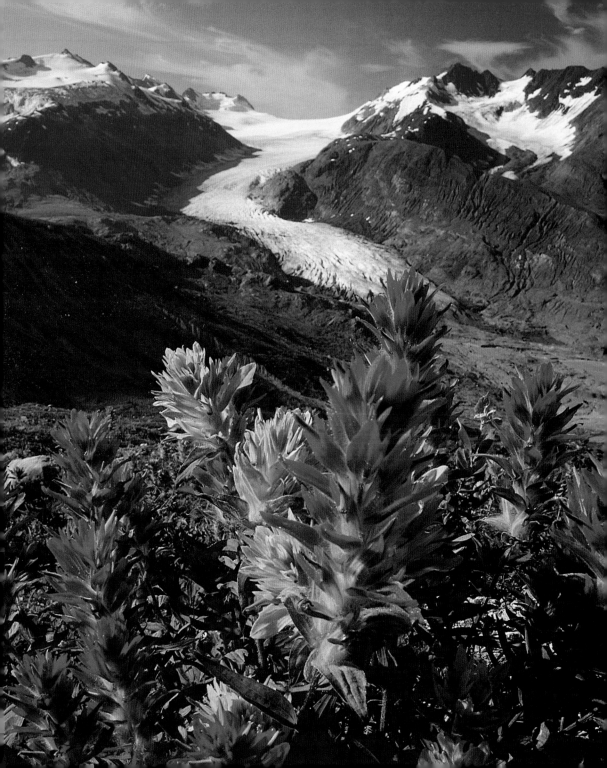

overleaf Chichagof Island, Tongass National Forest

left Giant red paintbrush *(Castilleja miniata),* Glacier Bay National Park and Preserve

right Bald eagles *(Haliaeetus leuco-cephalus)* roosting on a tree snag, Alaska Chilkat Bald Eagle Preserve

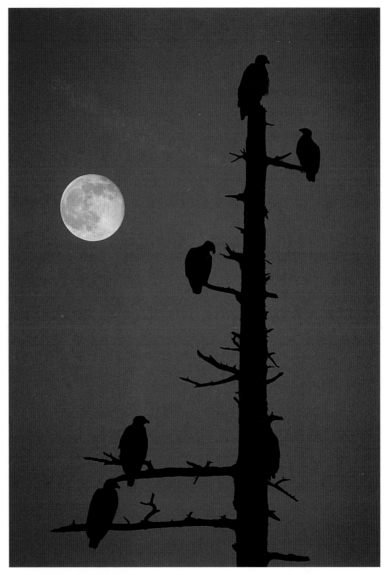

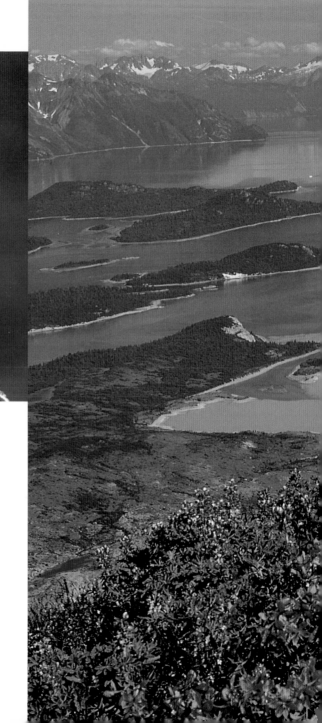

above Tufted puffin (*Fratercula cirrhata*), Glacier Bay National Park and Preserve

right Gilbert Inlet, Glacier Bay National Park and Preserve

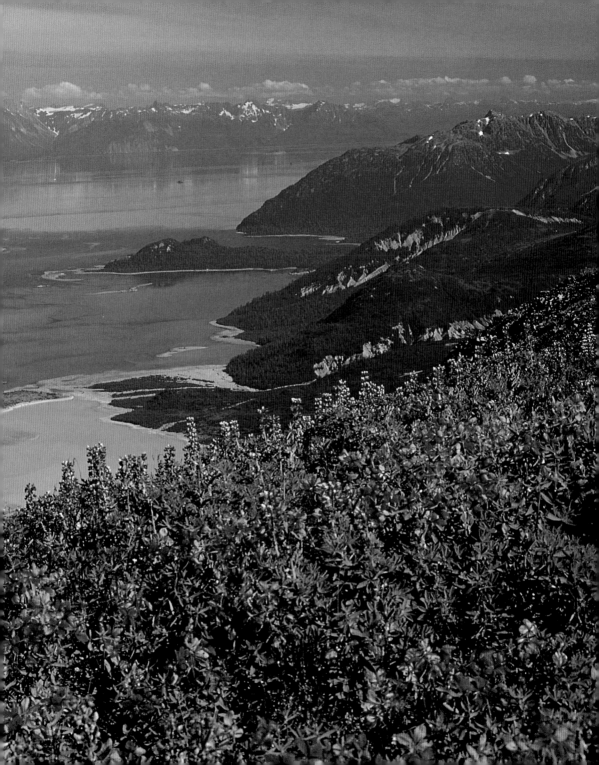

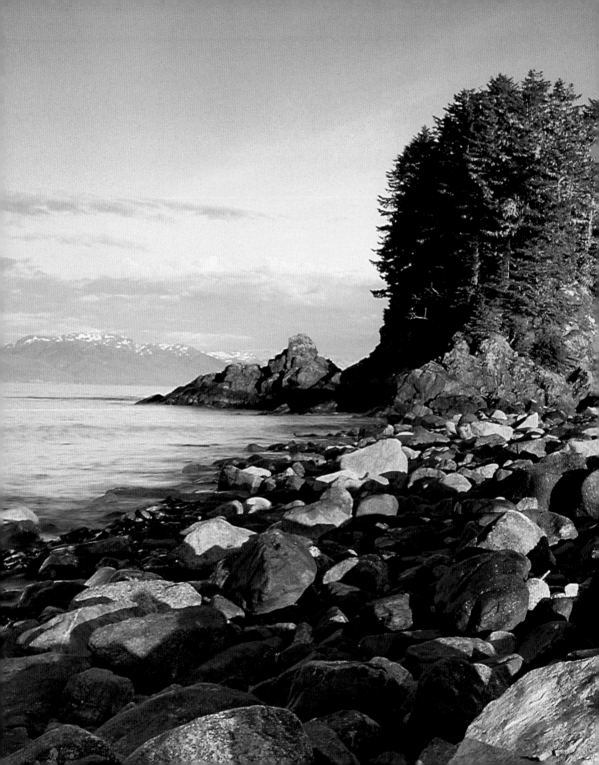

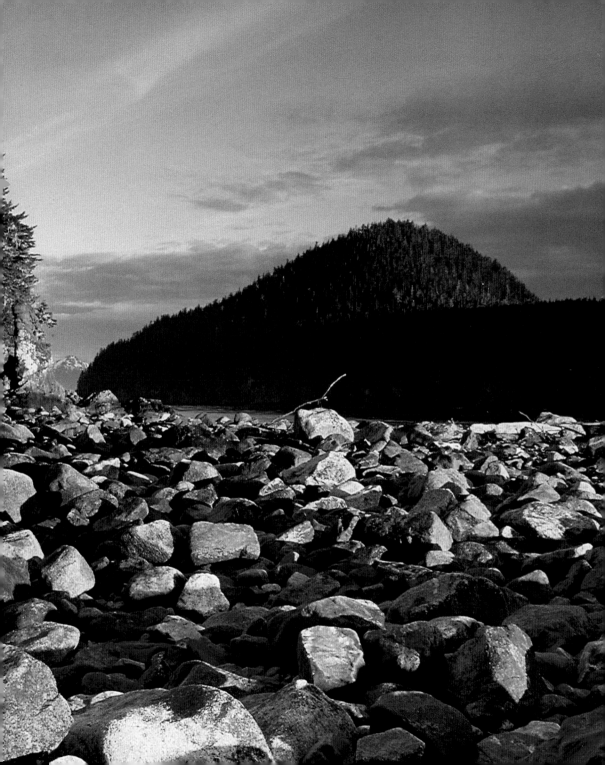

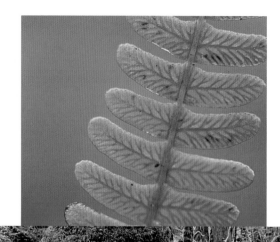

overleaf Sea stack, Taylor Bay, Glacier Bay National Park and Preserve

left Fern frond detail, Chichagof Island, Tongass National Forest

below Temperate rain forest bog, The Brothers, Tongass National Forest

right Glacial kettle, Bartlett Cove, Glacier Bay National Park and Preserve

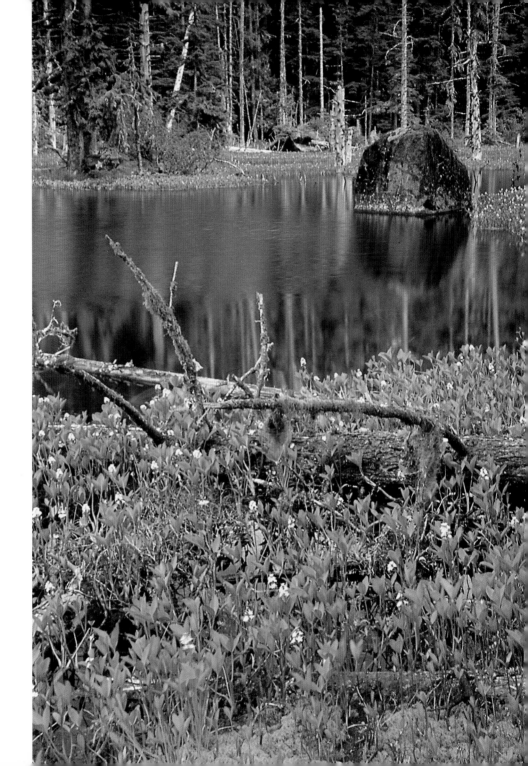

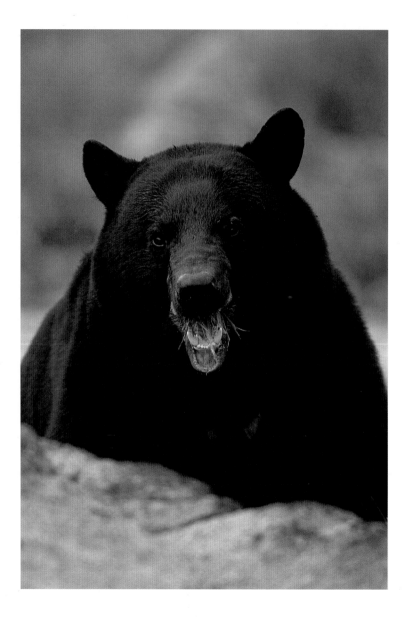

left Black bear *(Ursus americanus)*, Glacier Bay National Park and Preserve

right Rainbow, Frederick Sound

10

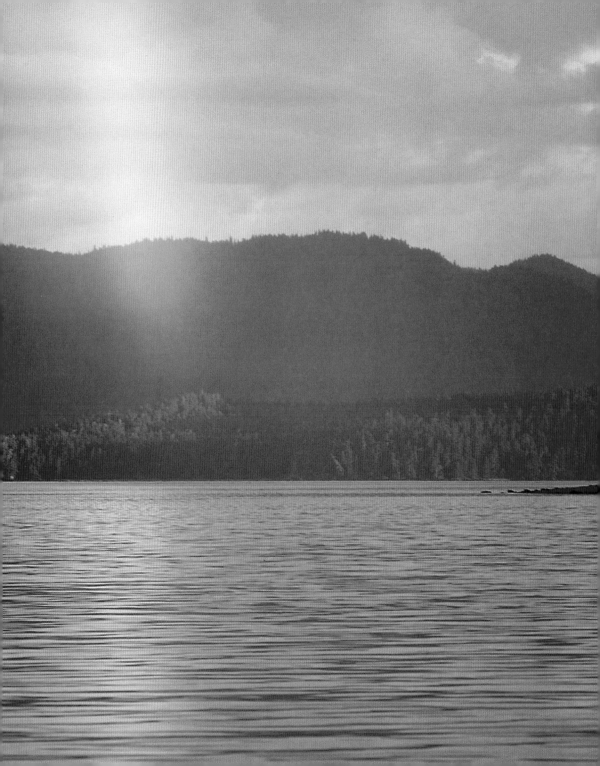

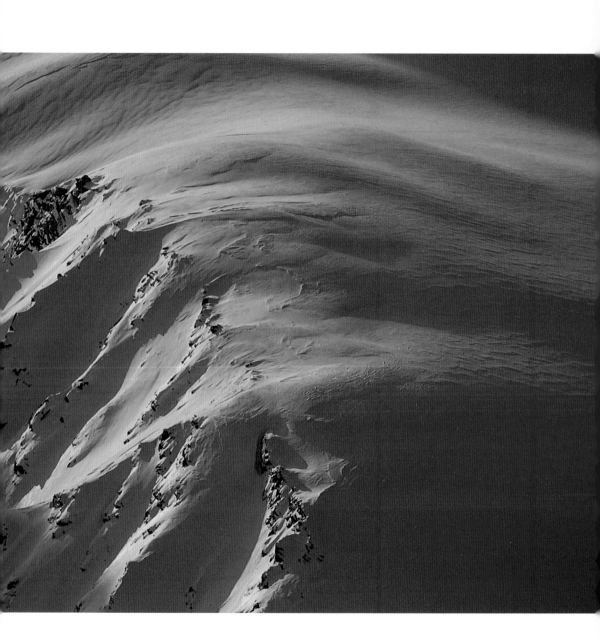

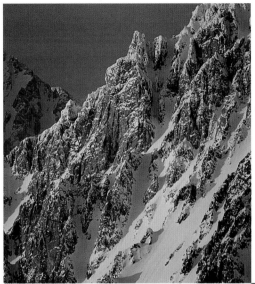

left Fairweather Range, Glacier Bay
National Park and Preserve

above Coast Mountains, Tongass
National Forest

right Aerial view of the Alsek Glacier,
Glacier Bay National Park and Preserve

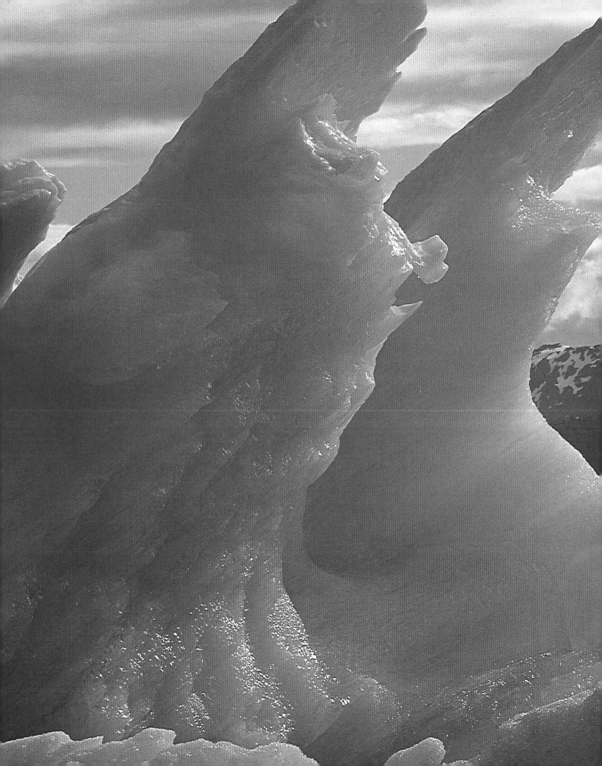

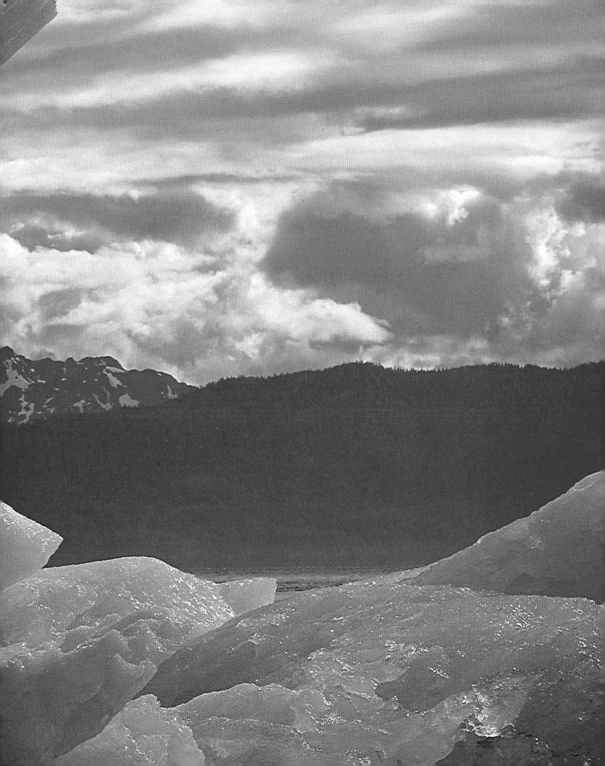

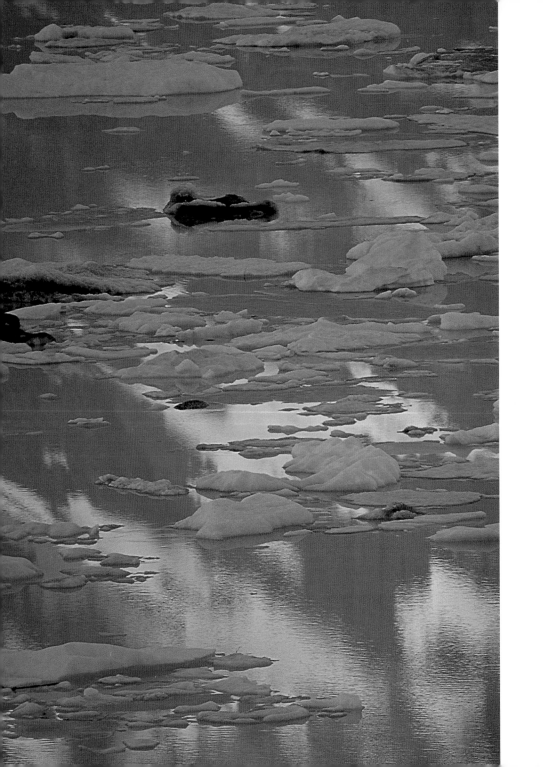

overleaf Iceberg, Tracy Arm, Tracy Arm-Fords Terror
Wilderness

left Icebergs calved from Alsek Glacier, Glacier Bay
National Park and Preserve

right Humpback whale *(Megaptera novaeangliae)*
fluke, Pt. Adolphus, Tongass National Forest

below Steller sea lions *(Eumetopias jubatus)*,
Glacier Bay National Park and Preserve

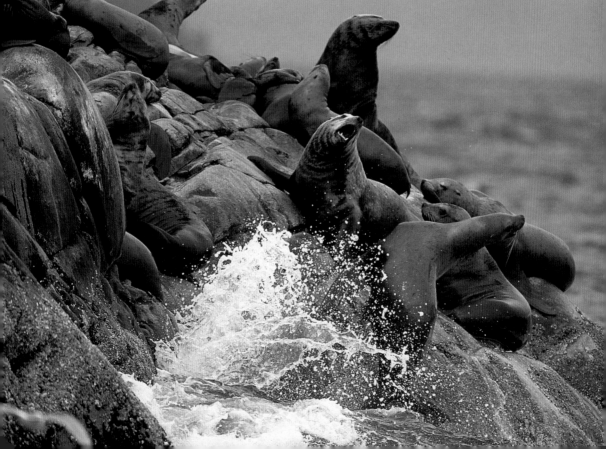

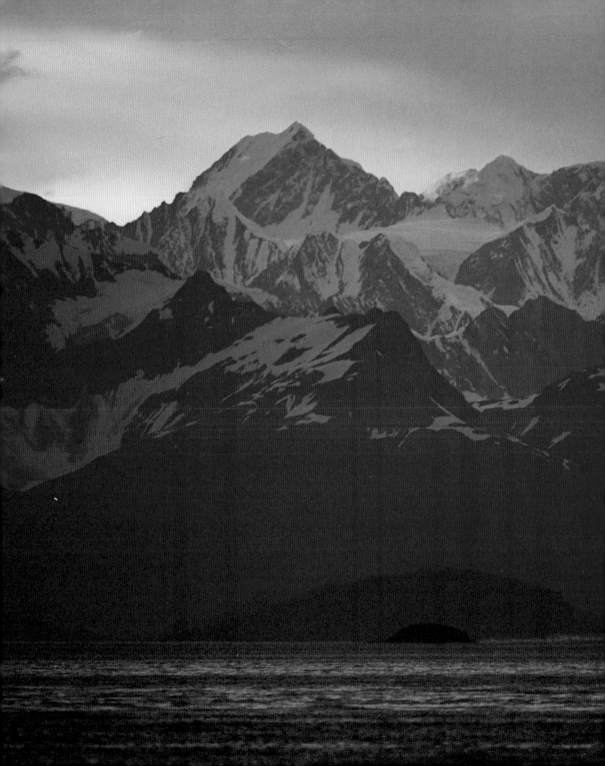

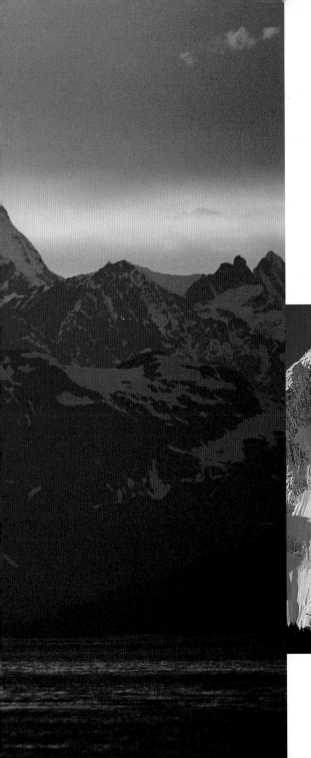

left Fairweather Range, Glacier Bay
National Park and Preserve

below Takhinsha Mountains from the
Alaska Chilkat Bald Eagle Preserve

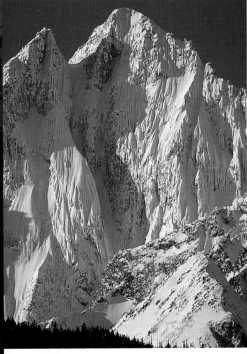

19

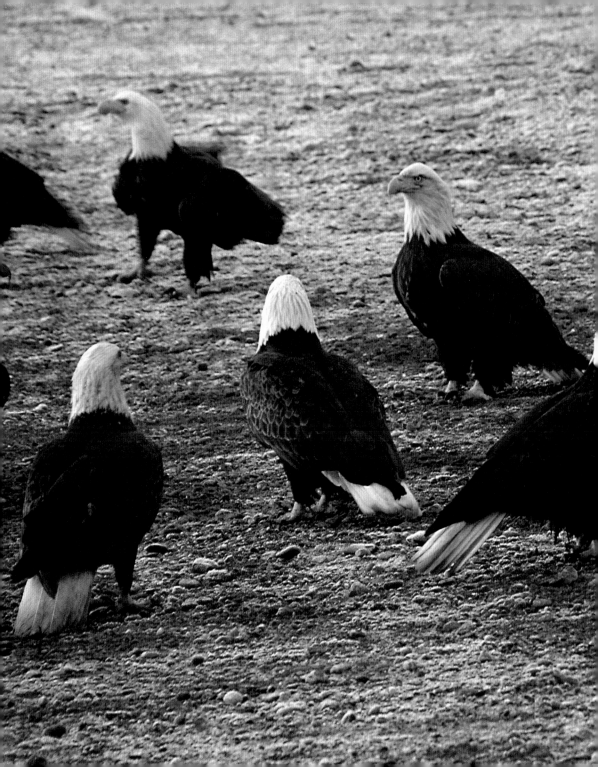

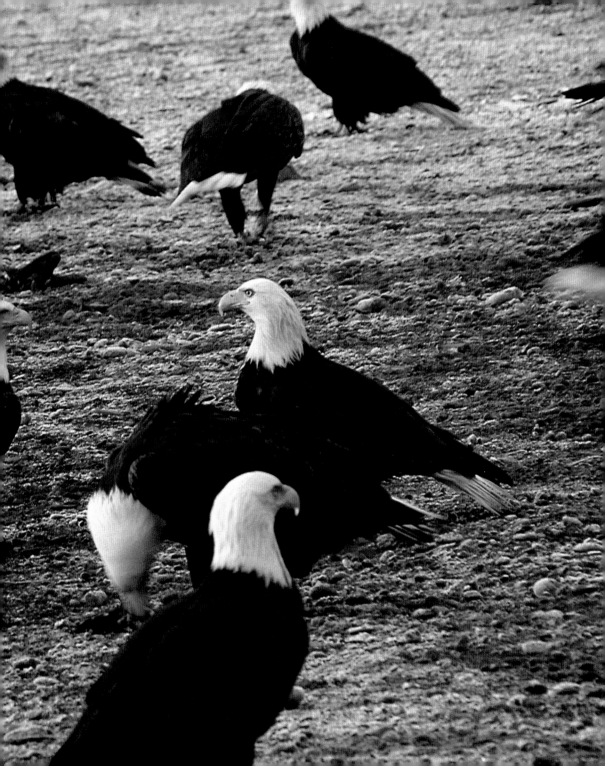

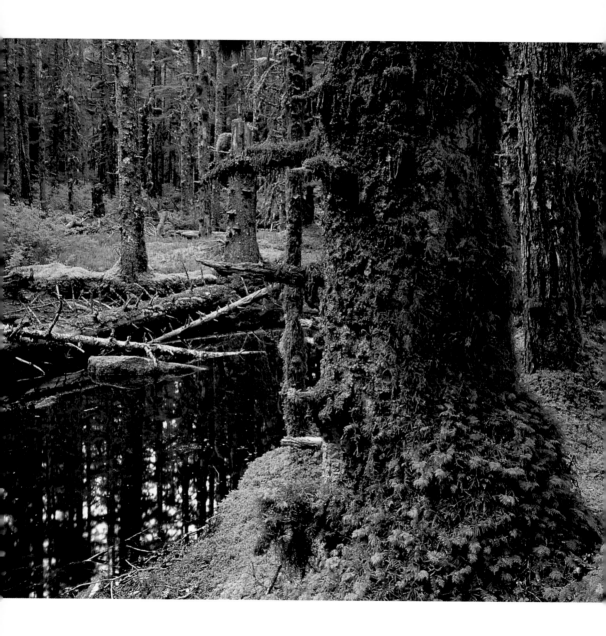

overleaf Bald eagles *(Haliaeetus leucocephalus)*, Alaska Chilkat Bald Eagle Preserve

left Temperate rain forest bog, Bartlett Cove, Glacier Bay National Park and Preserve

right Lily pad, Chichagof Island, Tongass National Forest

below Sphagnum moss, Glacier Bay National Park and Preserve

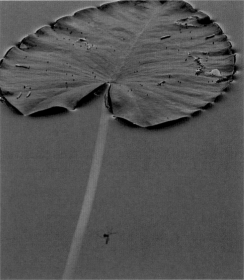

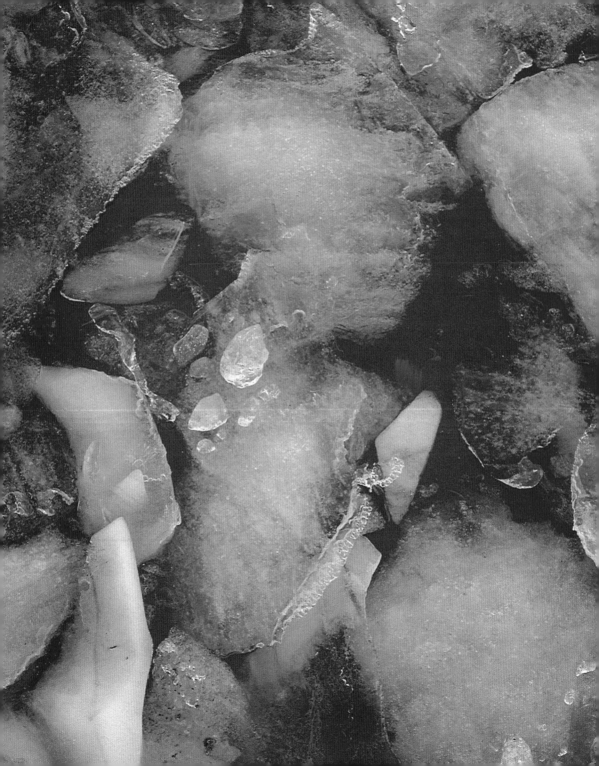

left Icebergs, Glacier
Bay National Park and
Preserve

right Waterfall, Tracy
Arm, Tracy Arm-Fords
Terror Wilderness

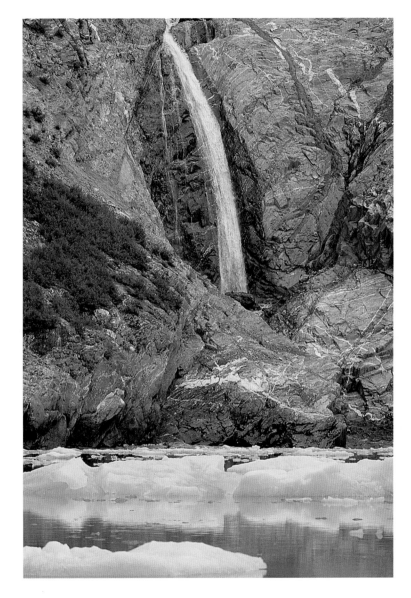

left Coastal landscape, Tongass National Forest

below Chichagof Island, Tongass National Forest

right Humpback whale *(Megaptera novaeangliae)*, Pt. Adolphus, Tongass National Forest

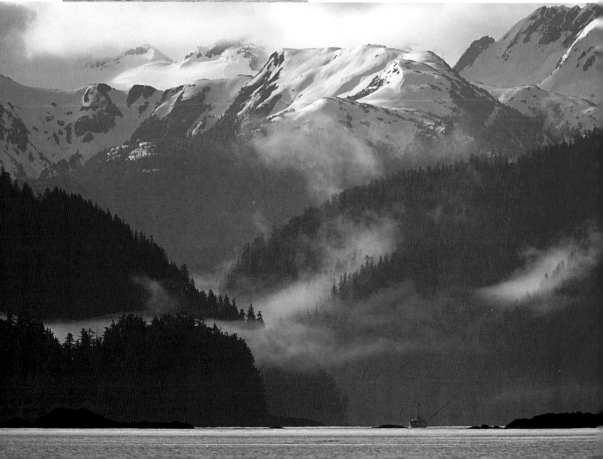

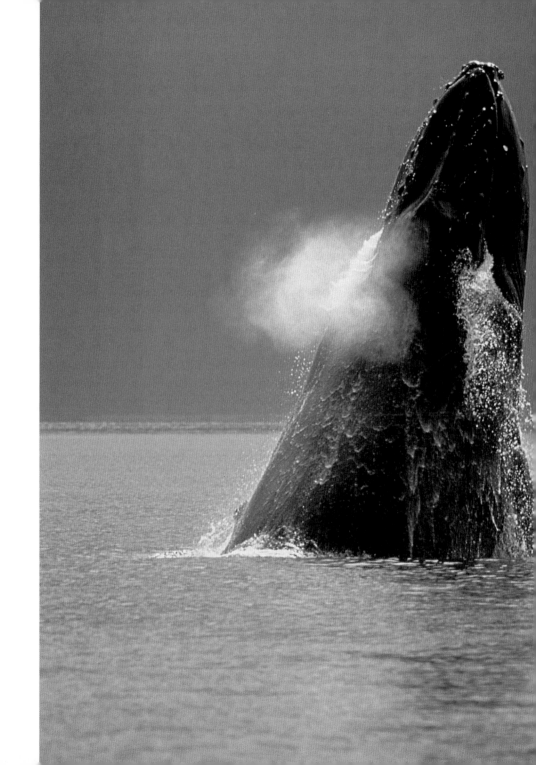

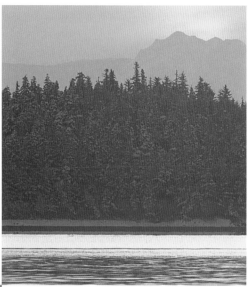

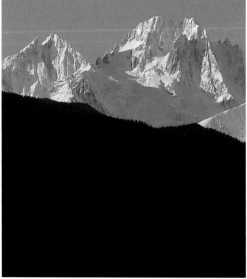

left Takhinsha Mountains from the Alaska Chilkat Bald Eagle Preserve

above Fairweather Range, Glacier Bay National Park and Preserve

right Mt. Fairweather, Fairweather Range, Glacier Bay National Park and Preserve

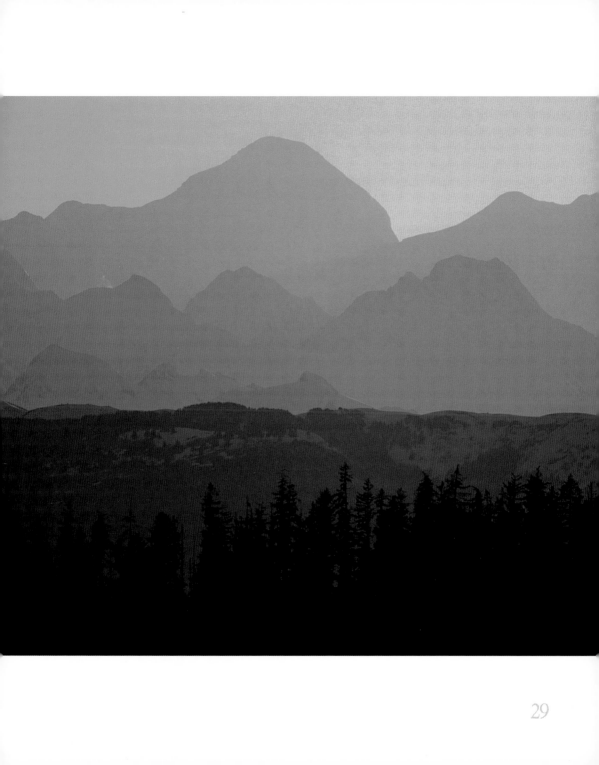

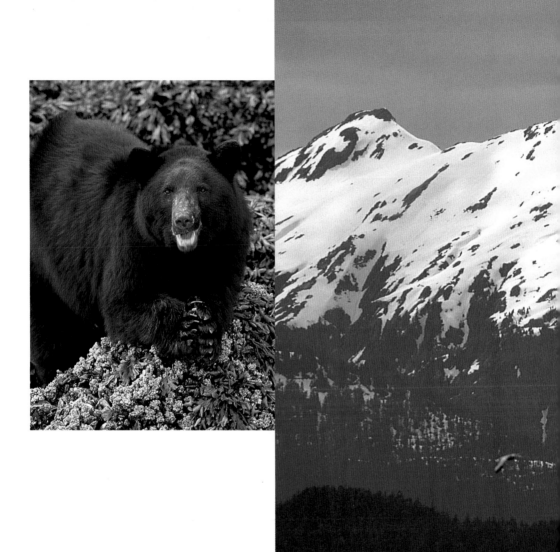

above Black bear *(Ursus americanus)* eating mollusks, Tongass National Forest

right Prince of Wales Island, Tongass National Forest

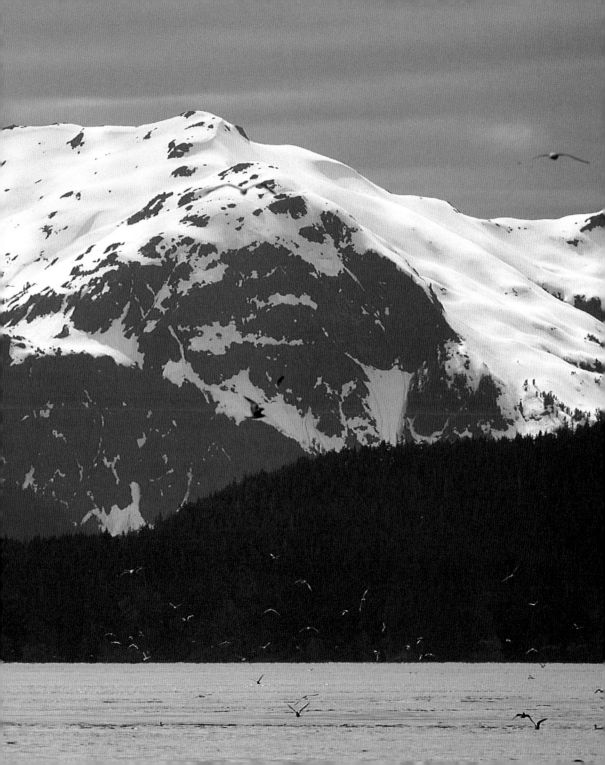

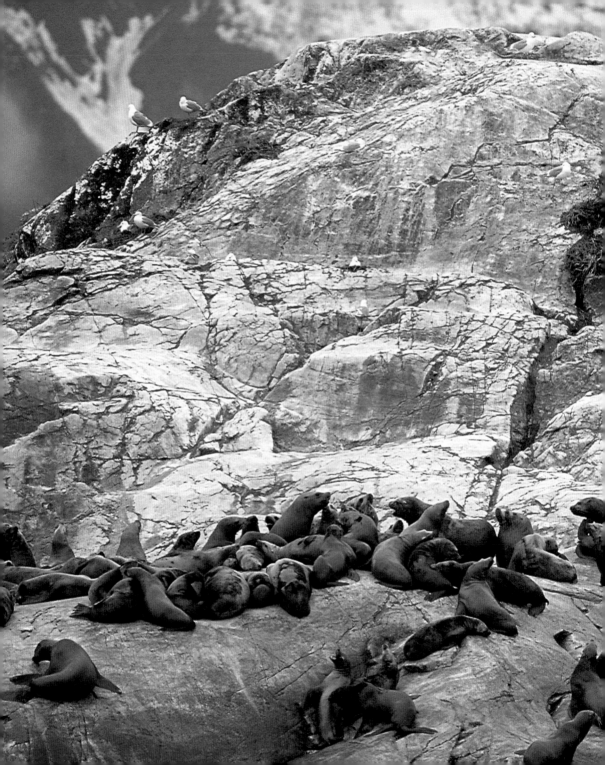

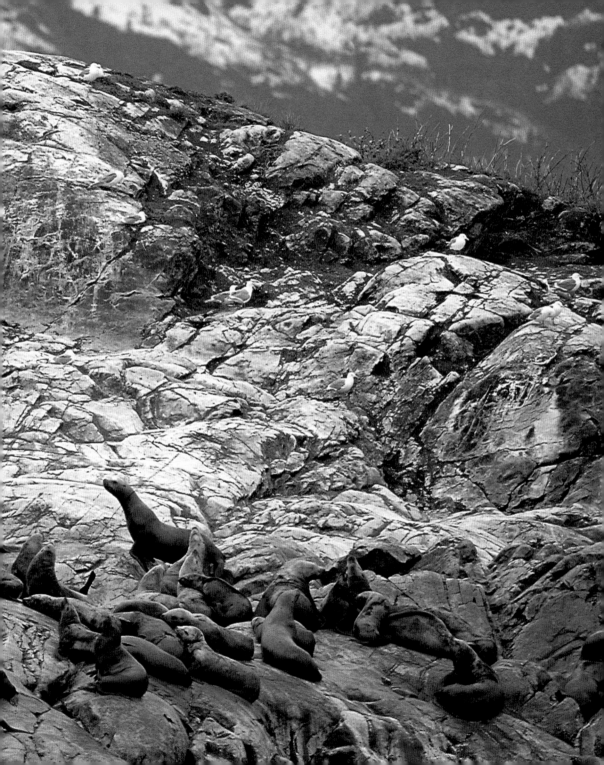

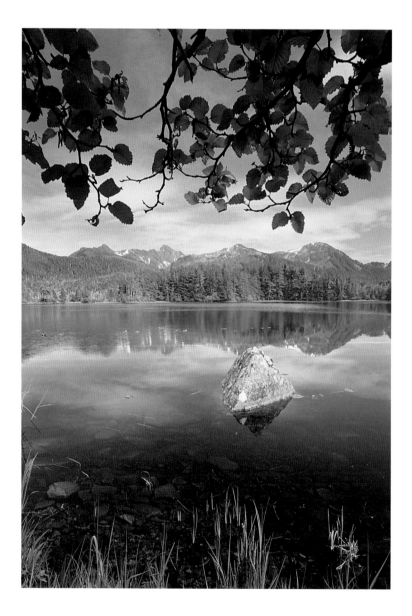

overleaf Steller sea
lions *(Eumetopias
jubatus)*, Glacier Bay
National Park and
Preserve

left Coastal lake,
Admiralty Island
National Monument-
Kootznoowoo
Wilderness

right Glacier bear
(Ursus americanus),
Glacier Bay National
Park and Preserve

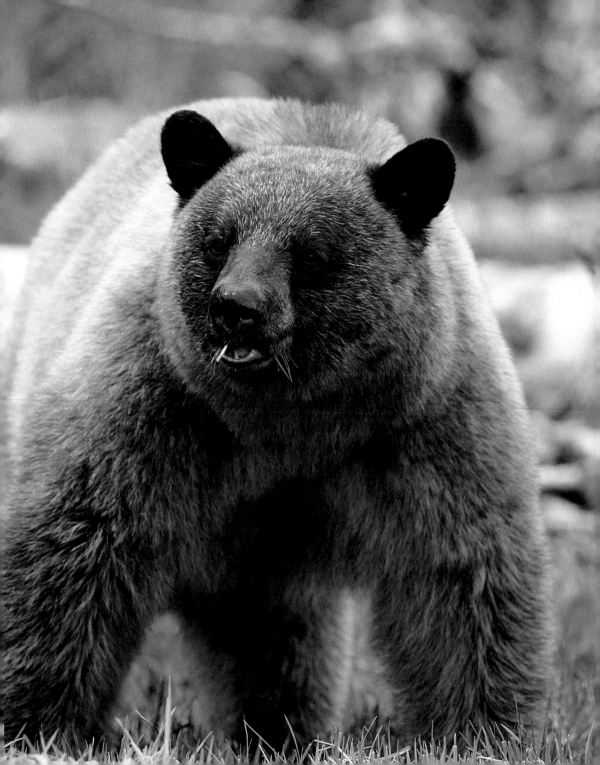

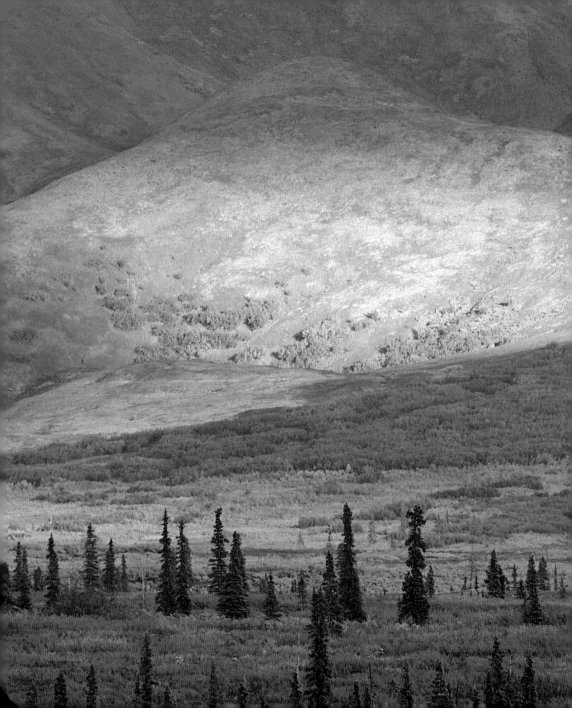

overleaf Fall colors, Alaska Range, Denali National Park and Preserve

below Arctic ground squirrel (*Spermophilus parryii*), Denali National Park and Preserve

right Devil's club and paper birch, Denali State Park

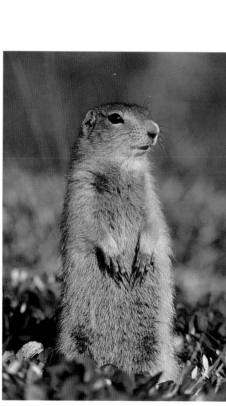

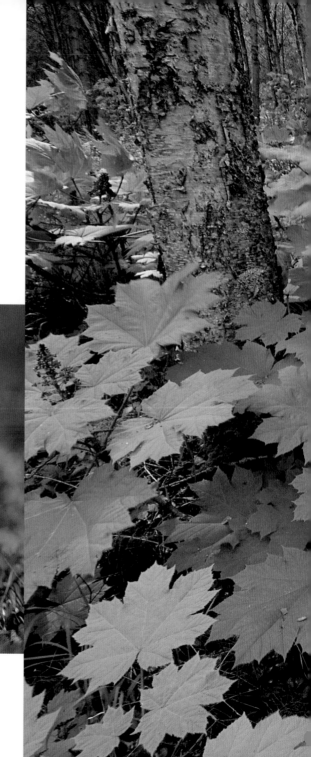

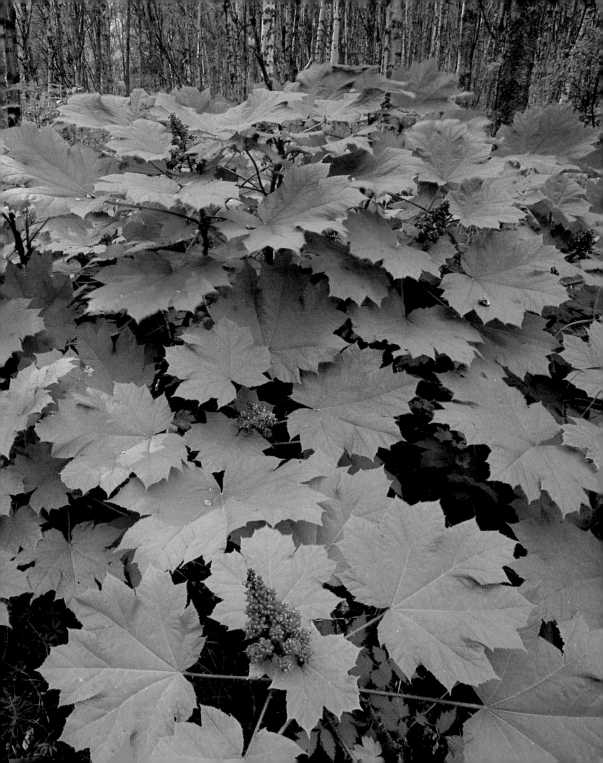

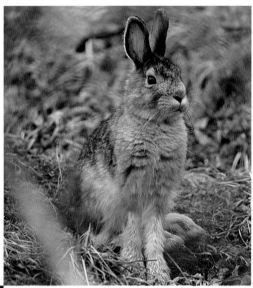

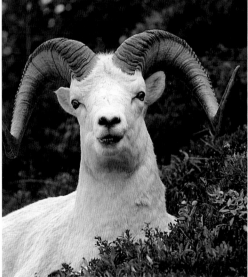

left Dall ram *(Ovis dalli)*, Denali National Park and Preserve

above Snowshoe hare *(Lepus americanus)*, Denali National Park and Preserve

right Mt. McKinley as viewed from Denali State Park

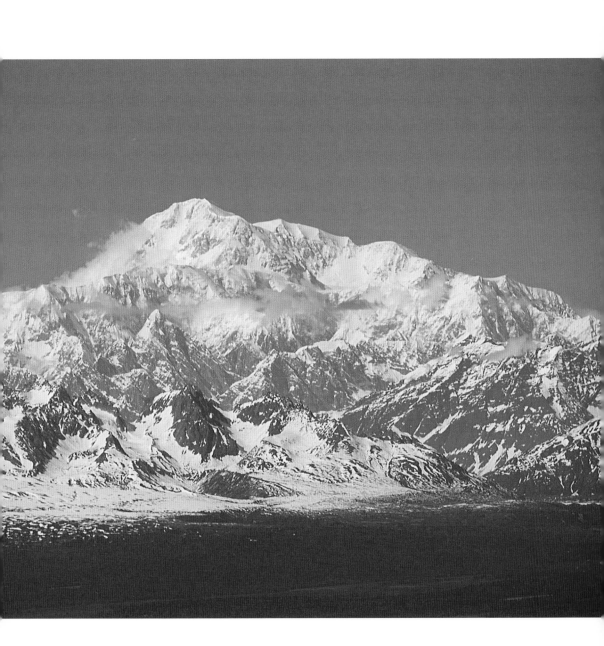

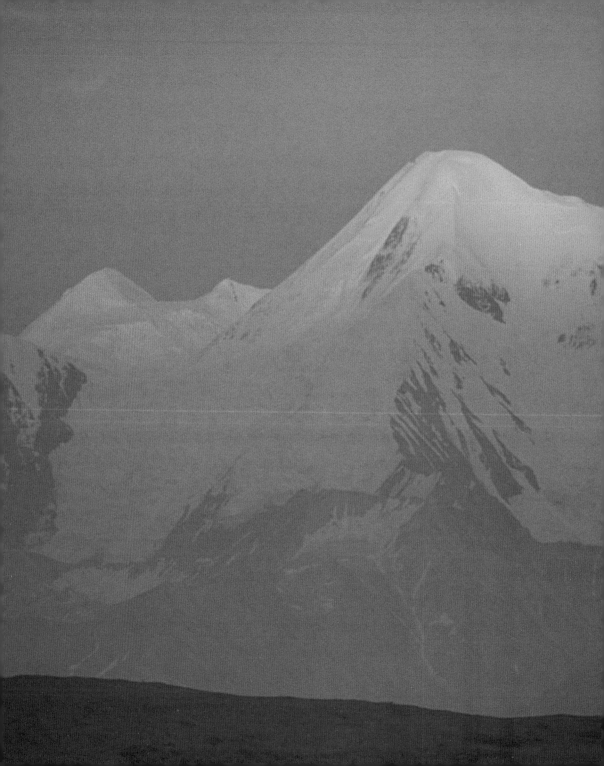

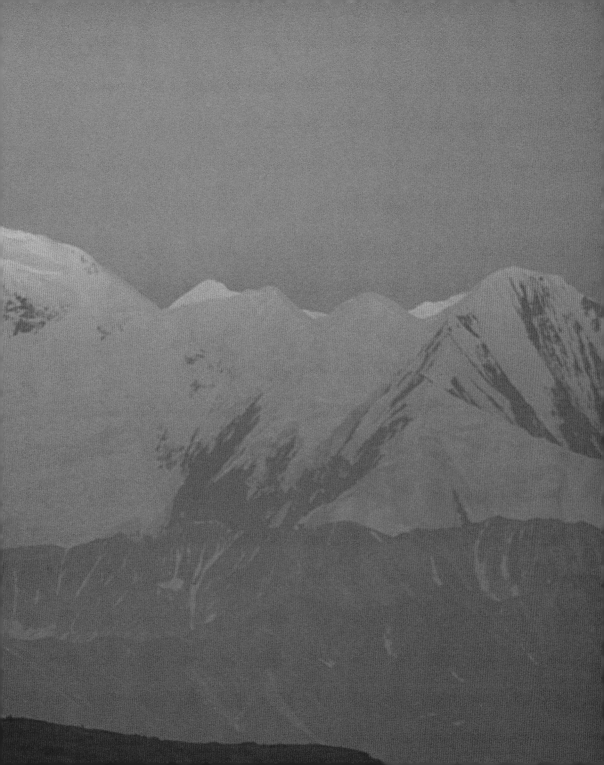

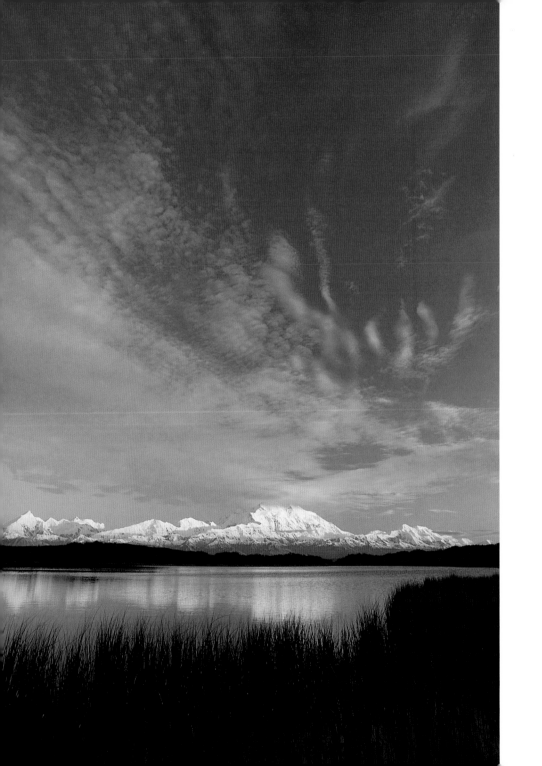

overleaf Alpenglow over the Alaska Range,
Denali National Park and Preserve

left Mt. McKinley, Wonder Lake, Denali
National Park and Preserve

right Gray wolf *(Canis lupus)*, Denali National
Park and Preserve

below Wetland, Denali State Park

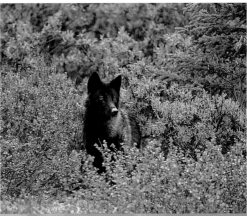

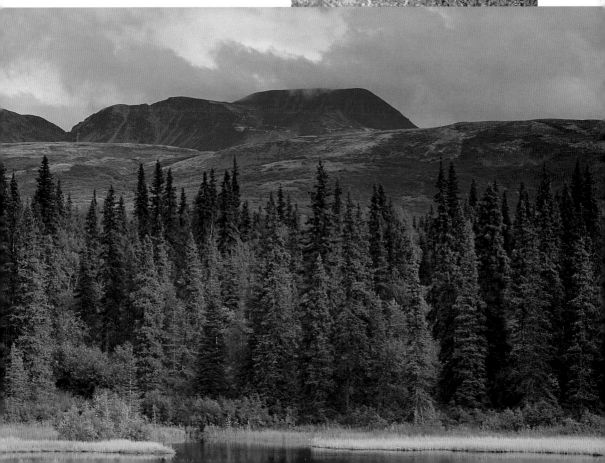

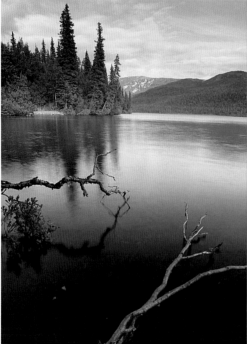

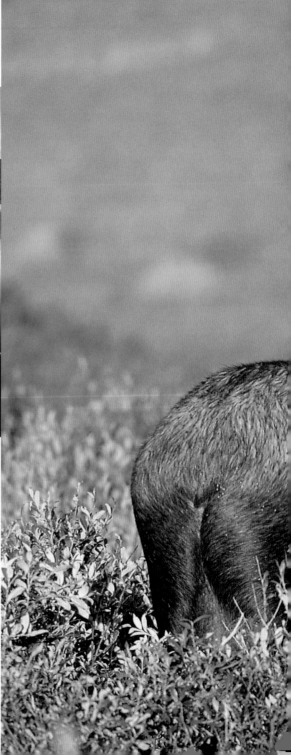

above Byers Lake, Denali State Park

right Bull moose *(Alces alces)*,
Denali National Park and Preserve

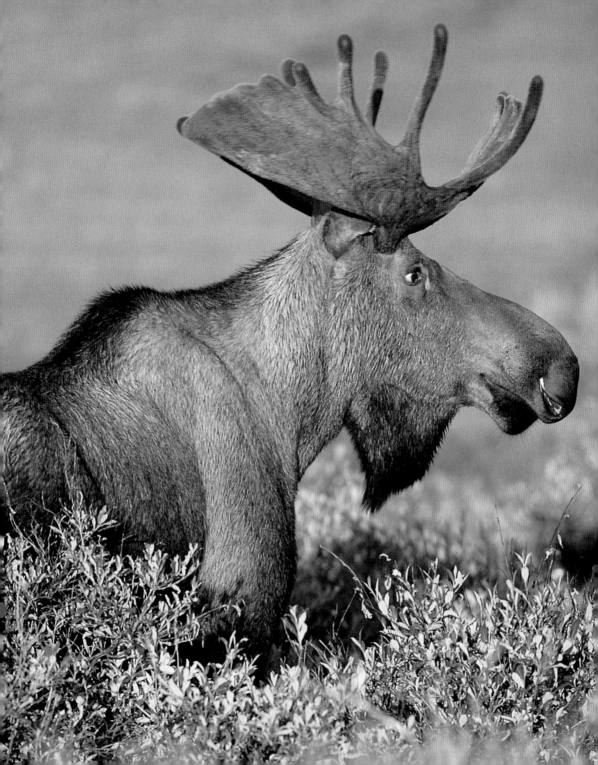

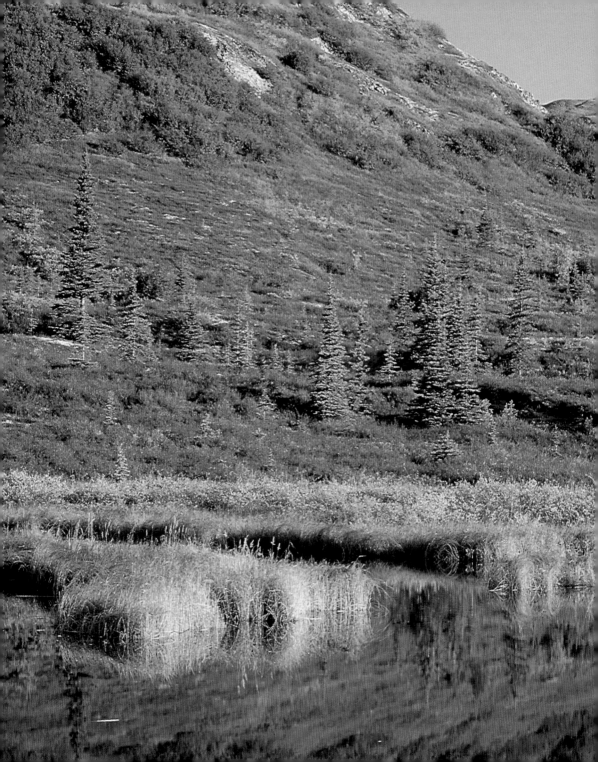

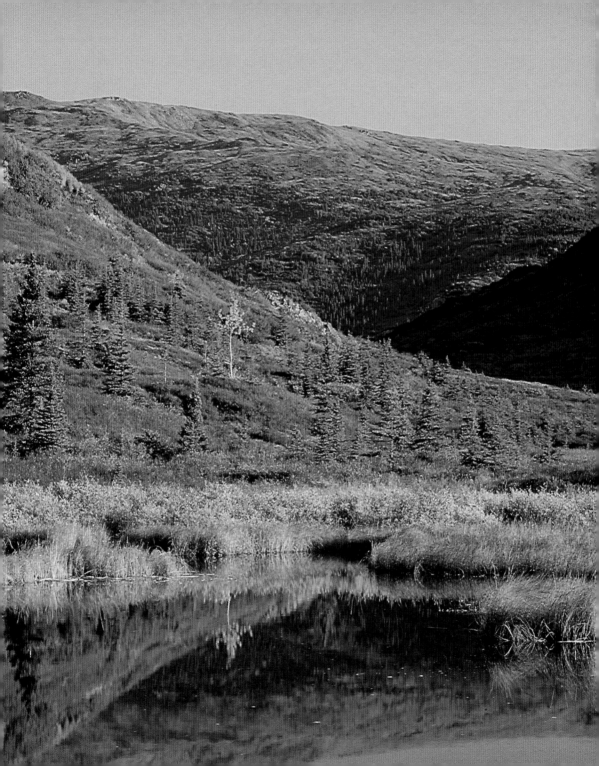

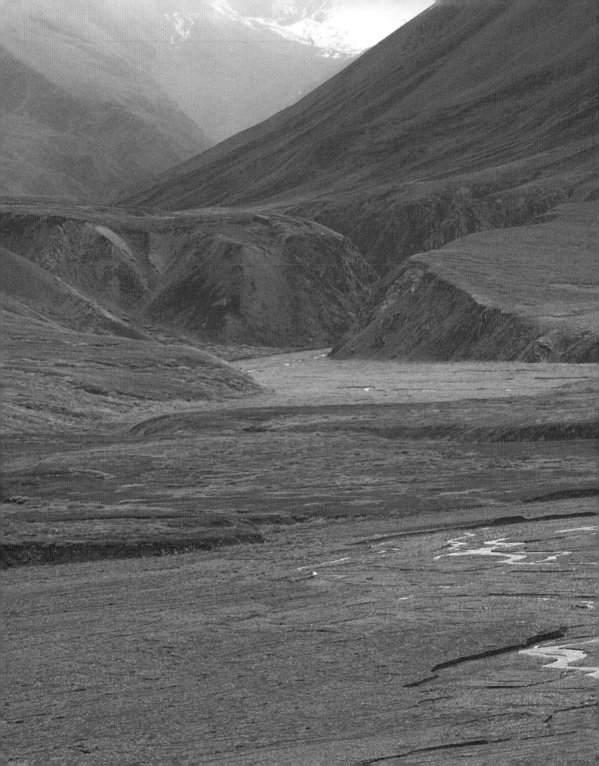

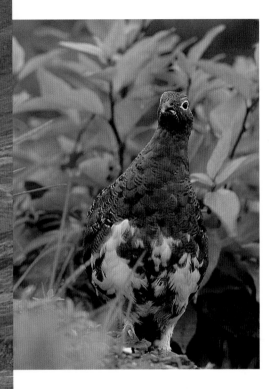

overleaf Fall colors reflected in beaver pond, Denali National Park and Preserve

left Fall colors, Thorofare River, Denali National Park and Preserve

above Willow ptarmigan *(Lagopus lagopus)*, Denali National Park and Preserve

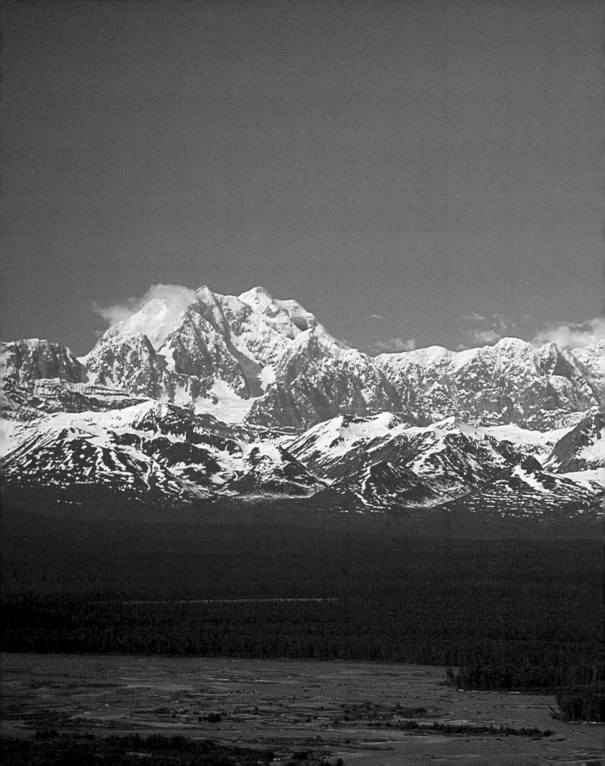

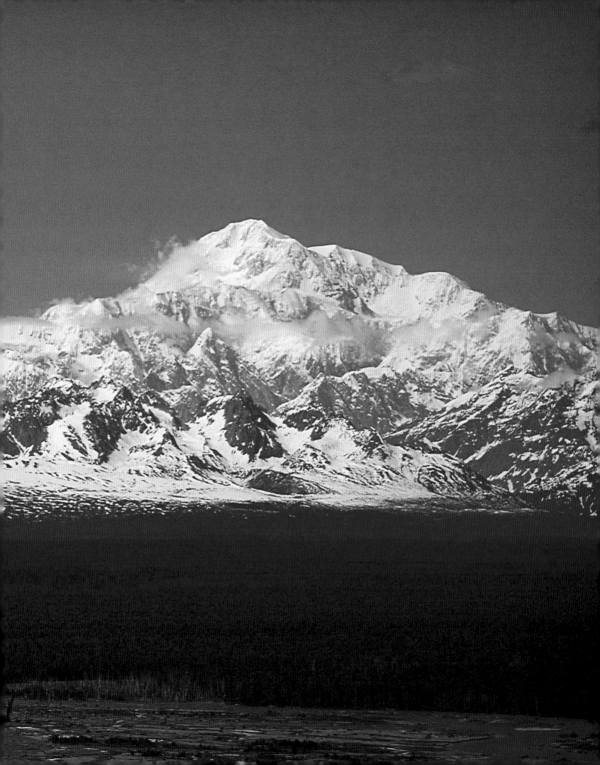

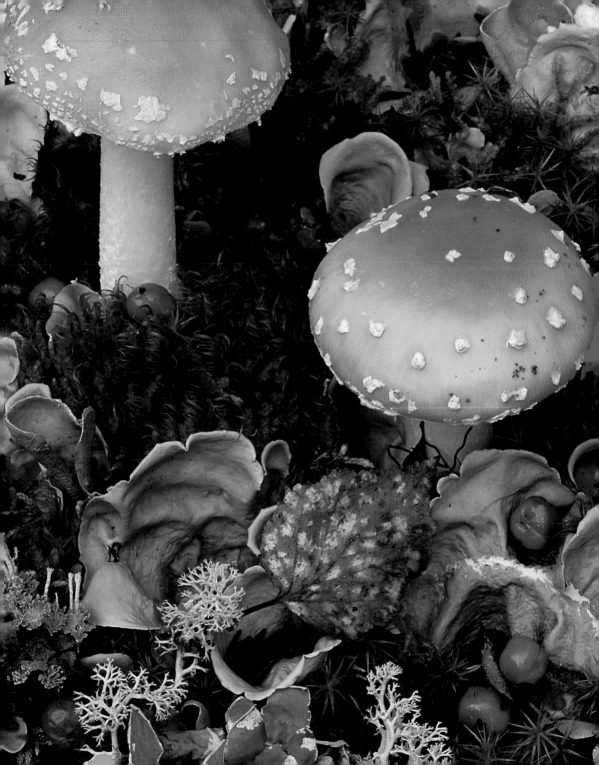

overleaf Mt. Foraker
and Mt. McKinley,
viewed from Denali
State Park

left Agaric fungus,
Denali National Park
and Preserve

right Little Coal Creek,
Denali State Park

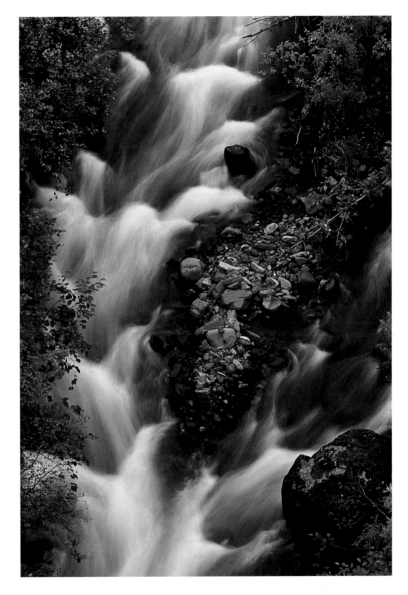

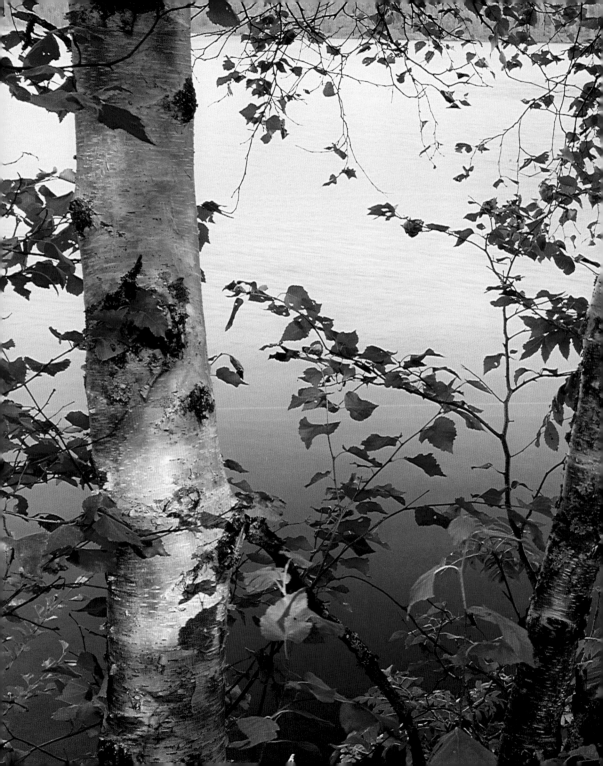

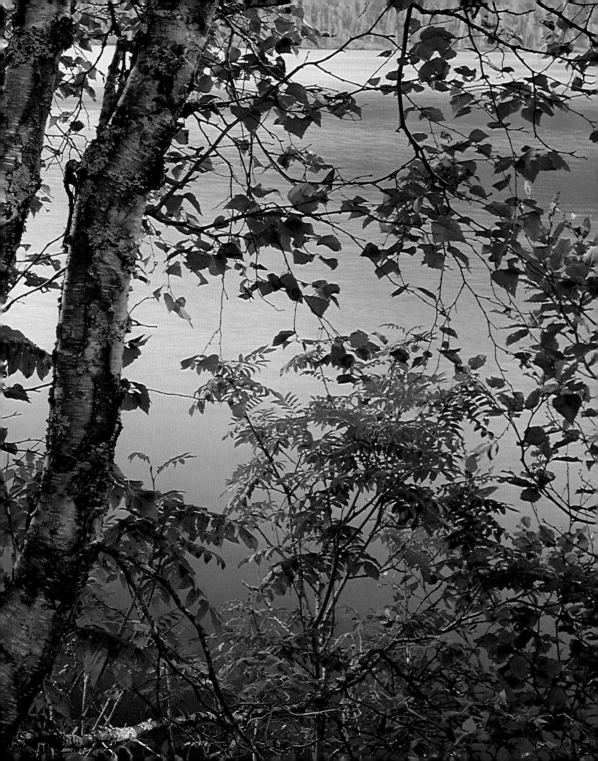

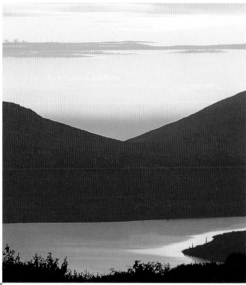

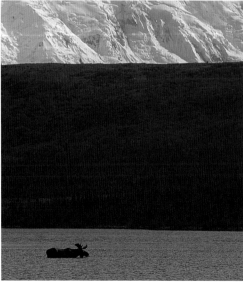

overleaf Paper birch and Byers Lake, Denali State Park

left, right Bull moose *(Alces alces)* feeding in Wonder Lake, Denali National Park and Preserve

above Wonder Lake, Denali National Park and Preserve

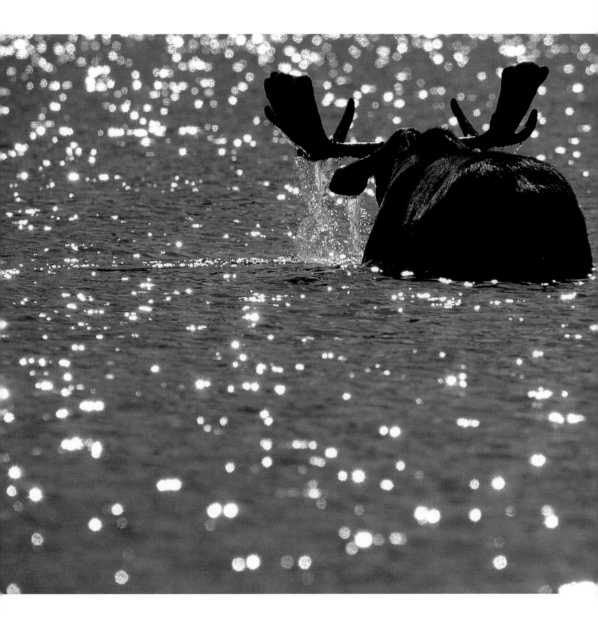

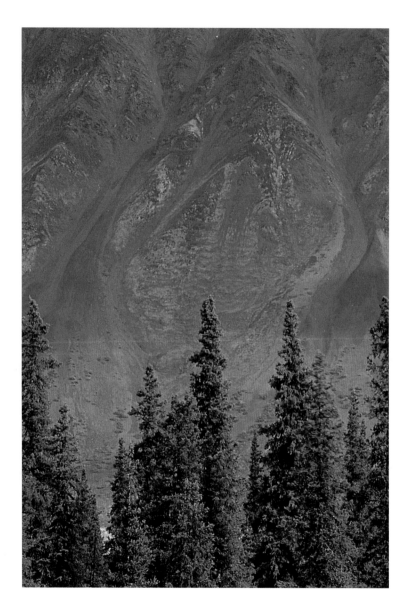

left Spruce forest,
Denali State Park

right Caribou bull
(*Rangifer tarandus*),
Denali National Park
and Preserve

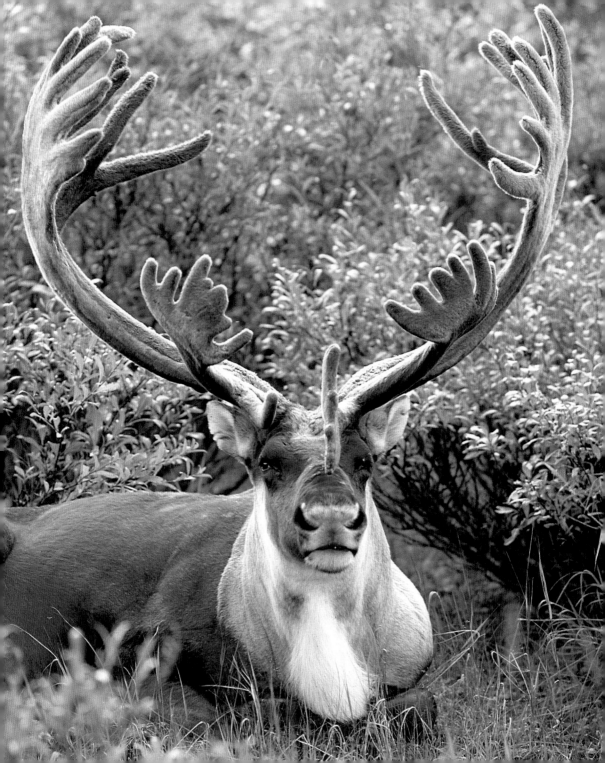

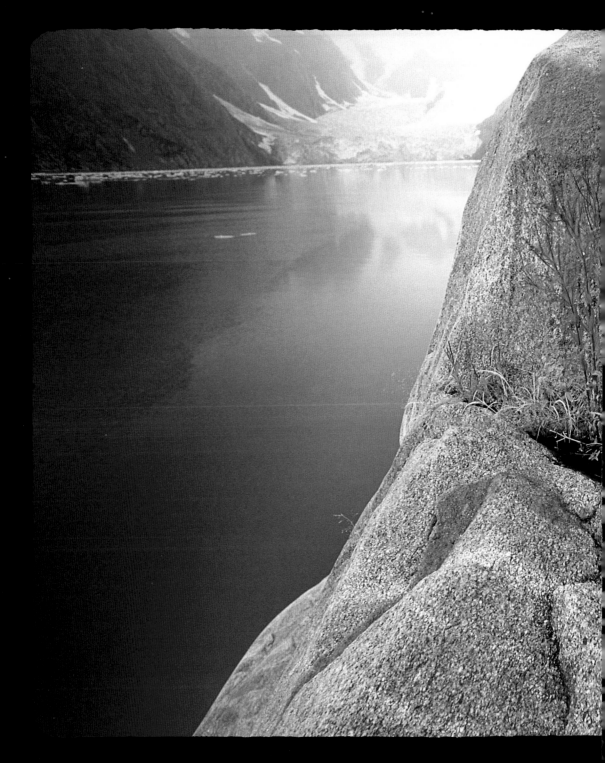

{ **south**central }

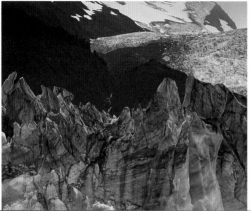

overleaf Granite, Northwestern Fjord, Kenai Fjords National Park

left Columbia Glacier, Chugach National Forest, Prince William Sound

below Harbor seals *(Phoca vitulina)*, Northwestern Fjord, Kenai Fjords National Park

right Canada lynx *(Felis canadensis)*, Chugach Mountains, Chugach State Park

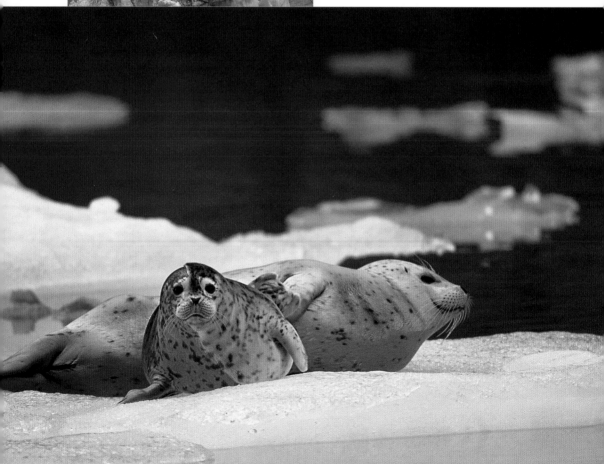

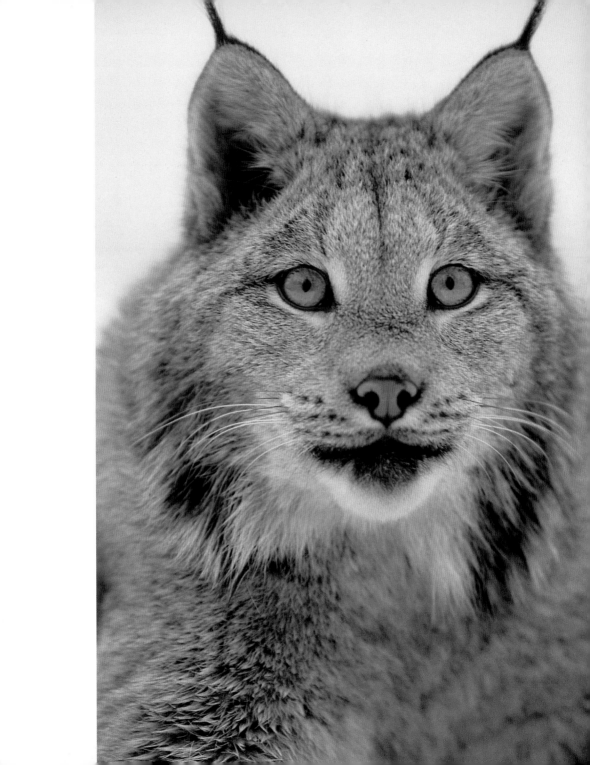

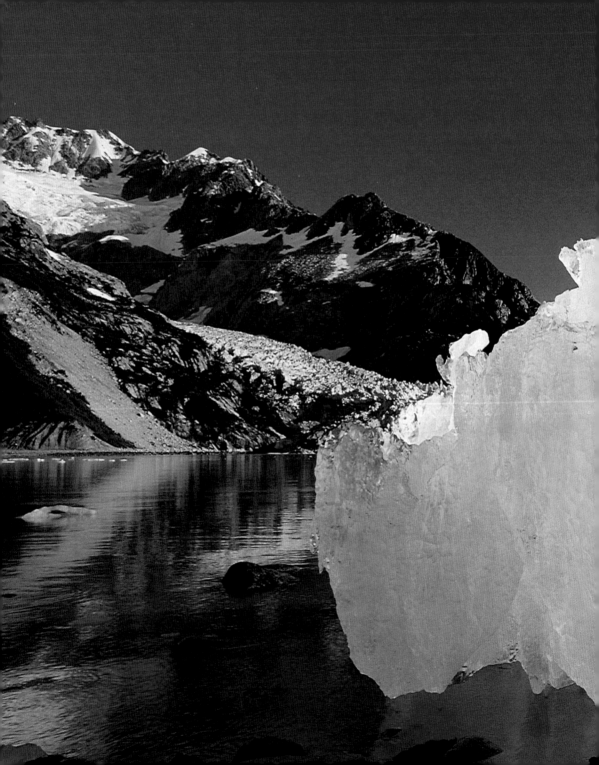

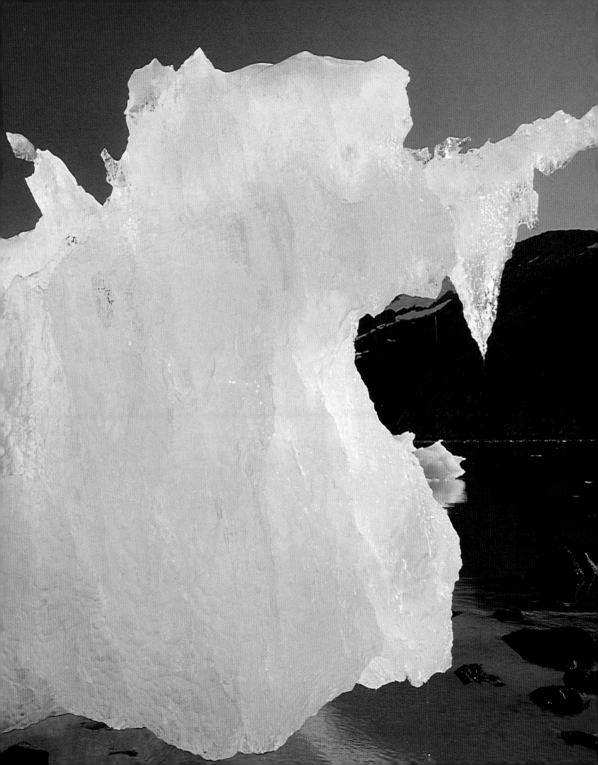

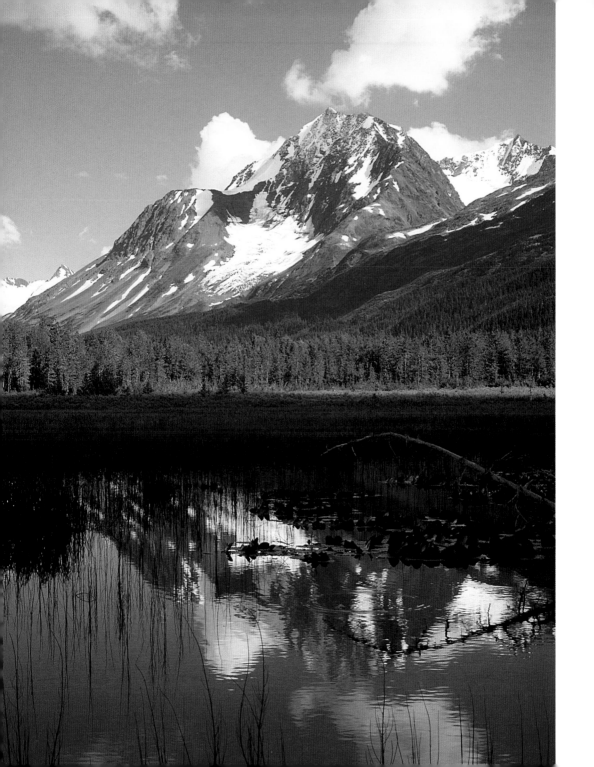

overleaf Iceberg, Northwestern Fjord,
Kenai Fjords National Park

left Kenai Mountains, Kenai National
Wildlife Refuge

right Black lily *(Fritillaria camschatcensis)*,
Eklutna Flats, Chugach State Park

below Trumpeter swan cygnet *(Cygnus buccinator)*, Kenai National Wildlife Refuge

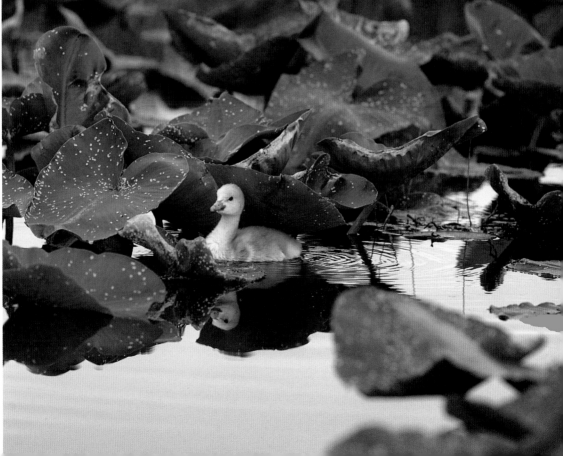

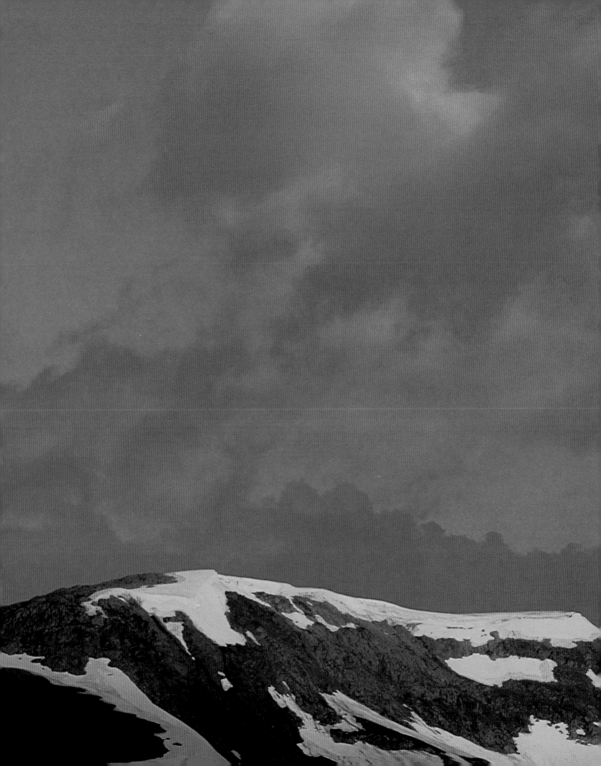

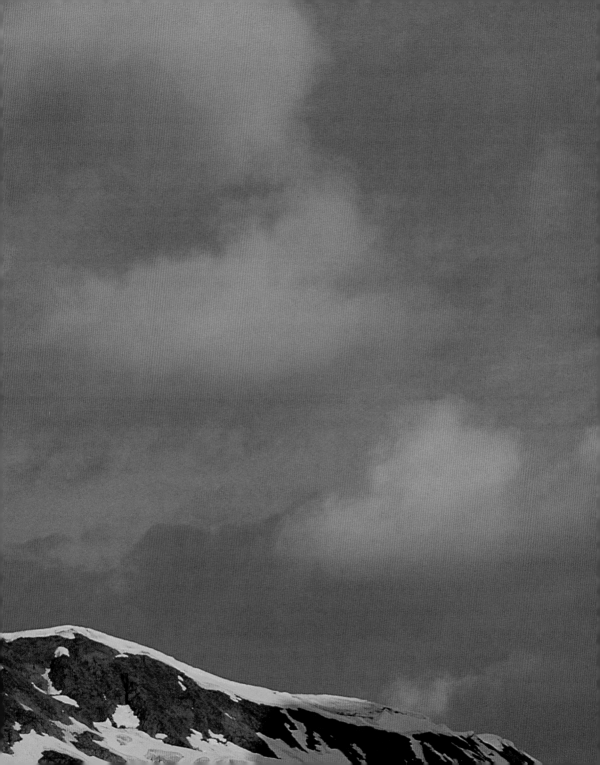

overleaf Chugach Mountains, Chugach
State Park

above Fireweed *(Epilobium angustifolium)*,
Kenai Fjords National Park

right Iris field *(Iris setosa)*, Eklutna Flats,
Chugach State Park

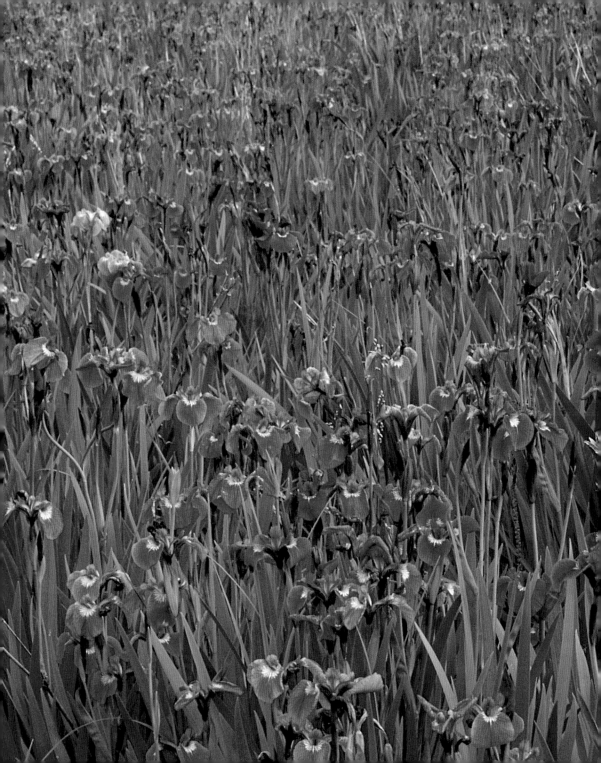

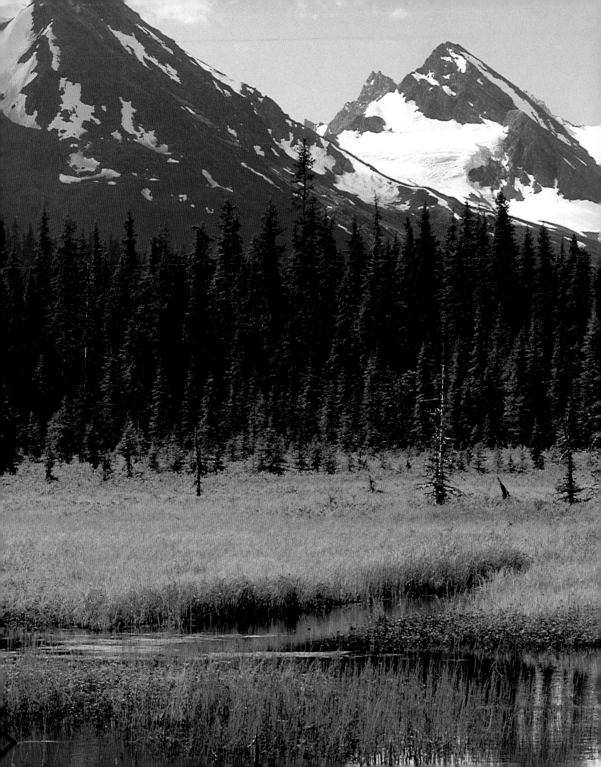

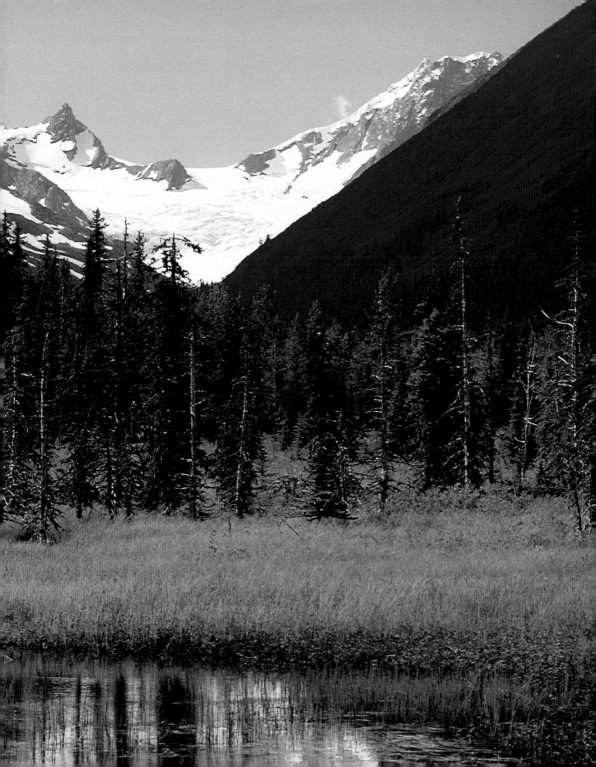

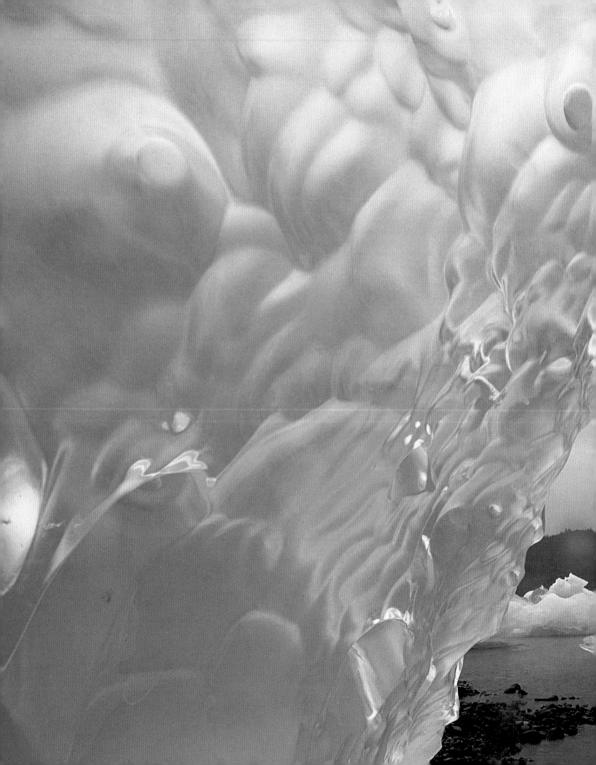

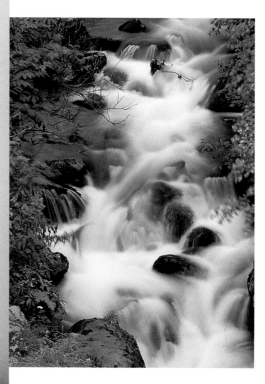

overleaf Kenai Mountains, Kenai
National Wildlife Refuge

left Icebergs, Columbia Bay, Prince
William Sound

above McHugh Creek, Chugach
State Park

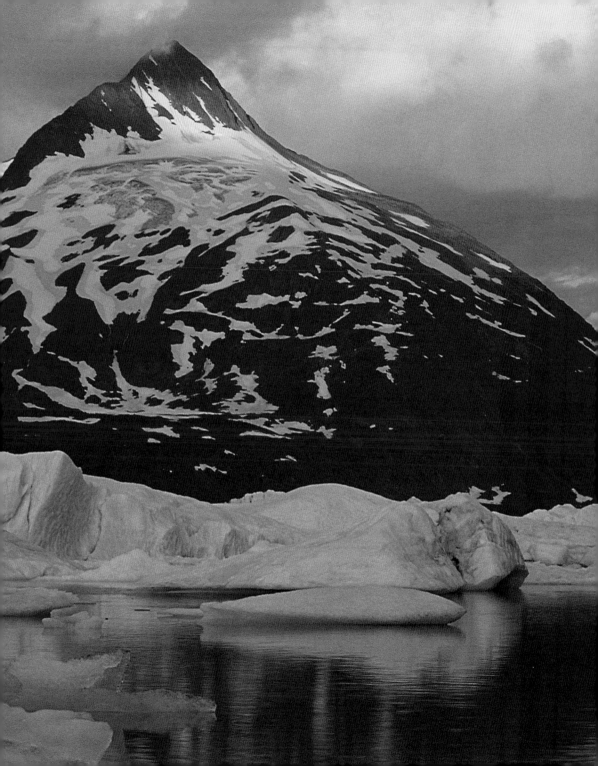

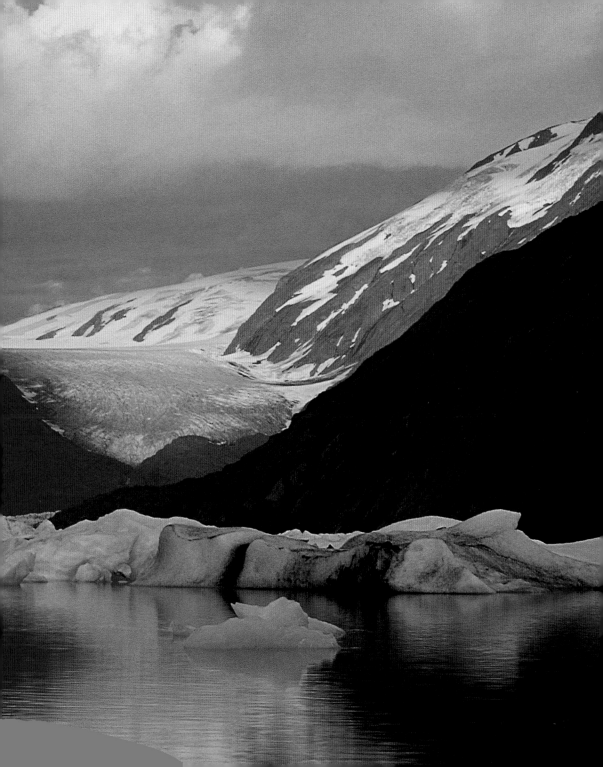

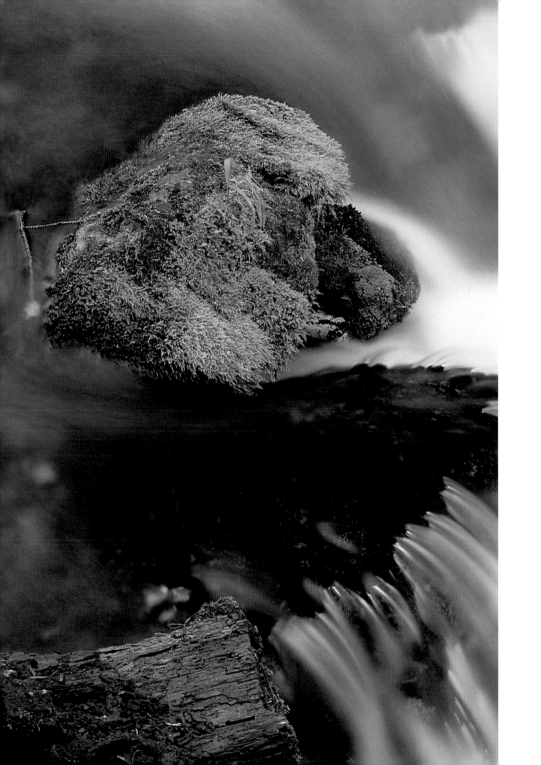

overleaf Portage Glacier, Kenai Peninsula

left McHugh Creek, Chugach State Park

right Devil's club overhanging McHugh Creek,
Chugach State Park

below Bench Creek, Chugach National Forest

next page Northwestern Fjord, Kenai Fjords
National Park

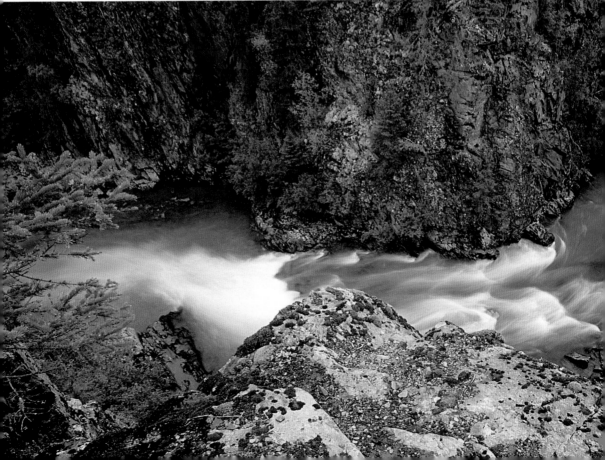

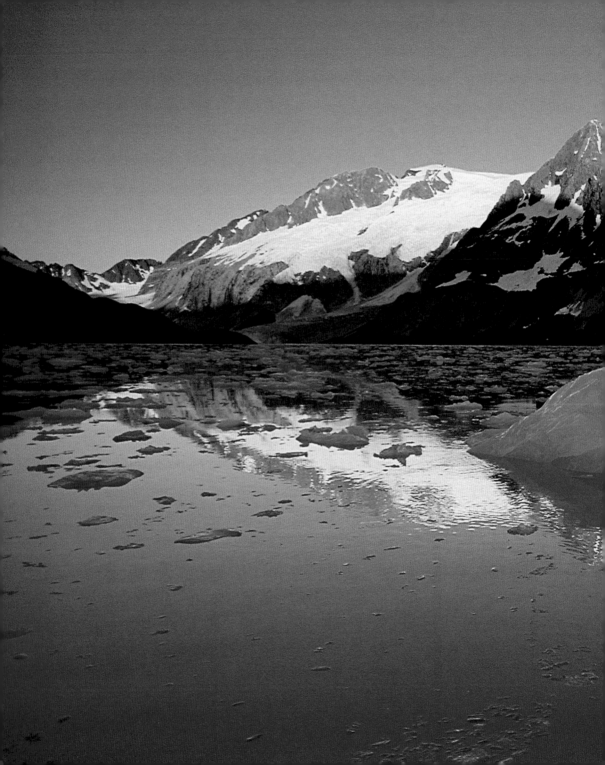

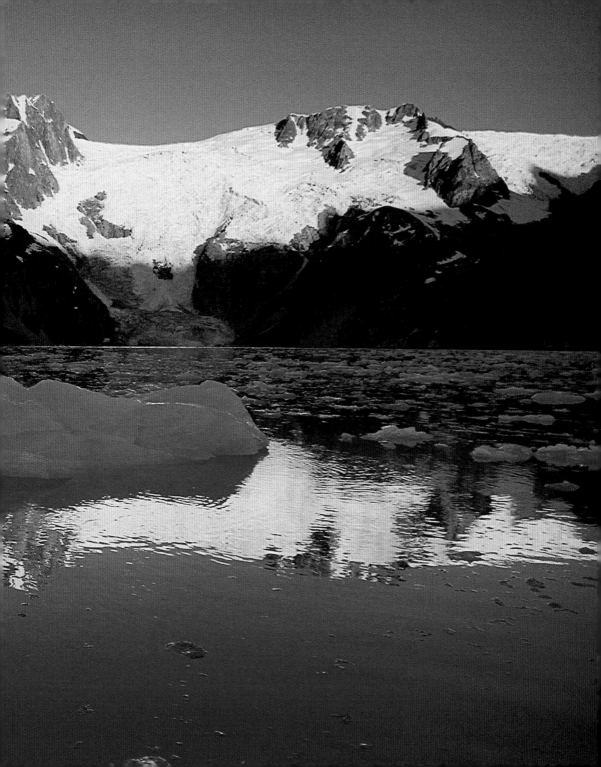

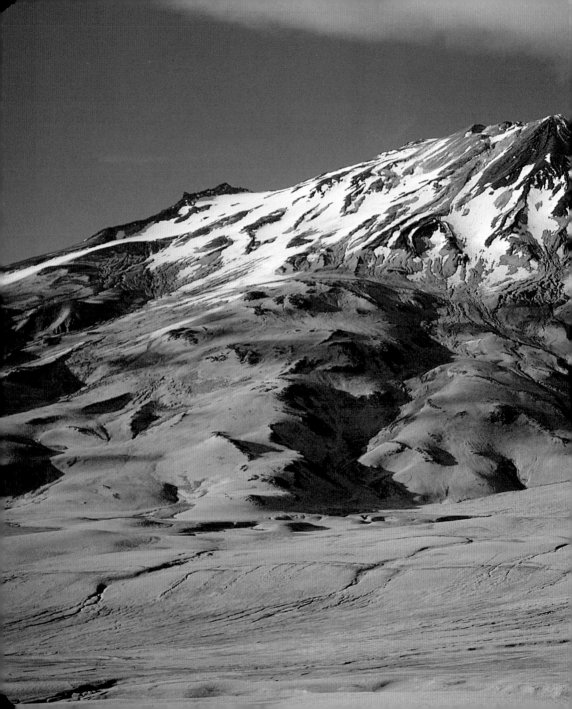

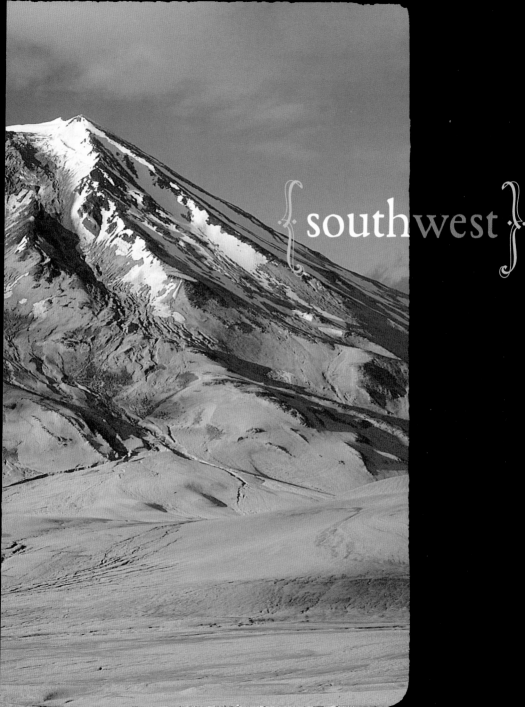

{ southwest }

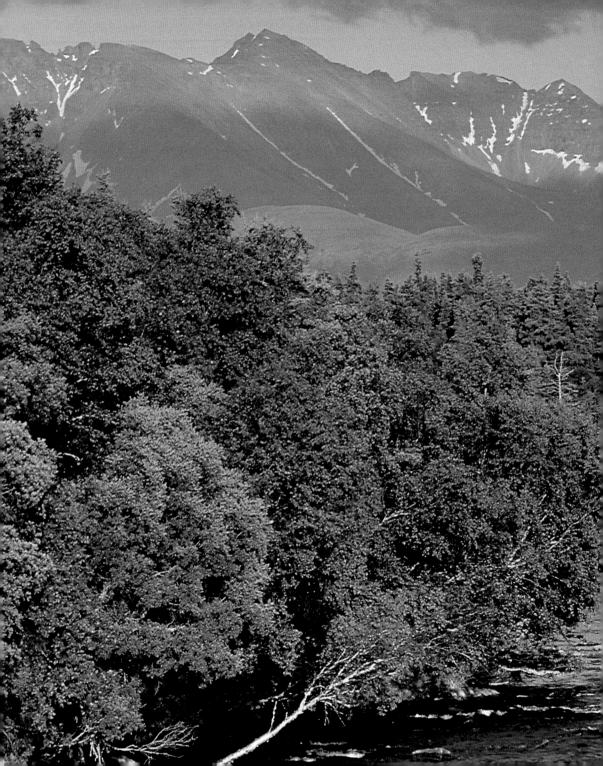

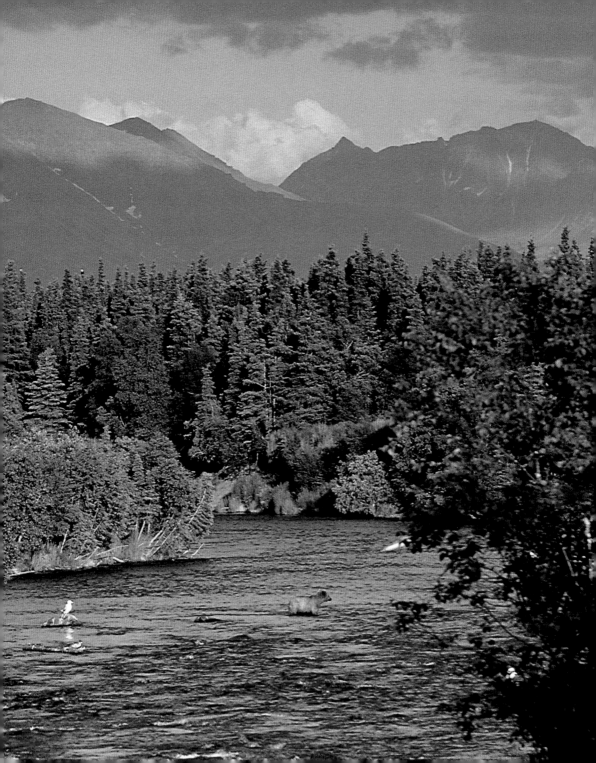

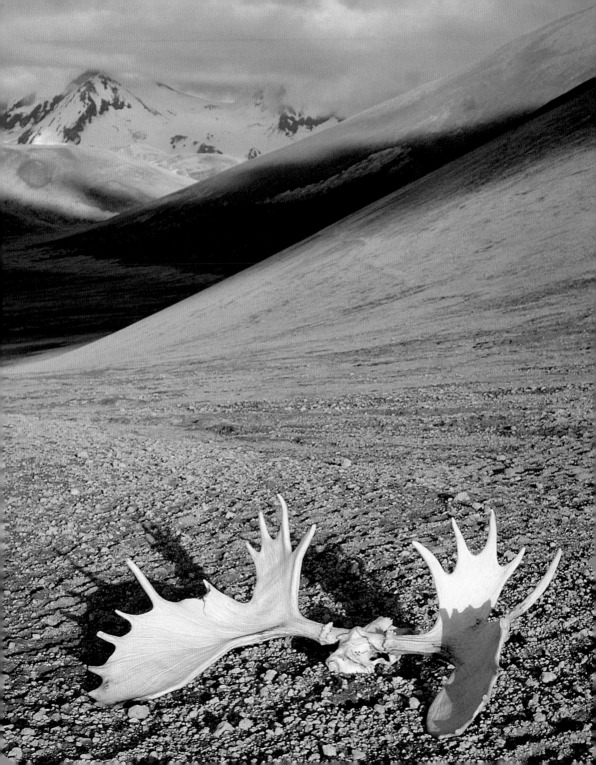

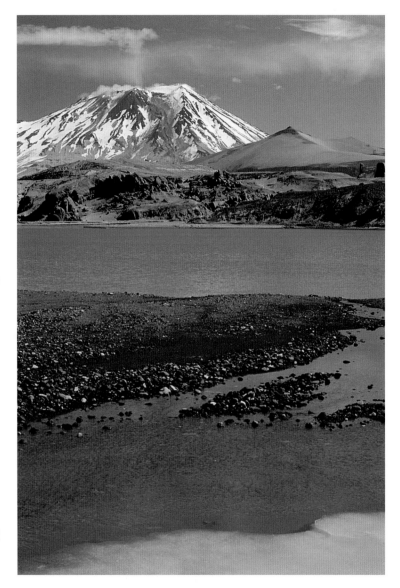

page 84 Mt. Griggs volcano, Valley of 10,000 Smokes, Katmai National Park and Preserve

page 86 Brown bear (*Ursus arctos*), Brooks River, Katmai National Park and Preserve

left Moose rack, Valley of 10,000 Smokes, Katmai National Park and Preserve

right Mount Griggs volcano, Valley of 10,000 Smokes, Katmai National Park and Preserve

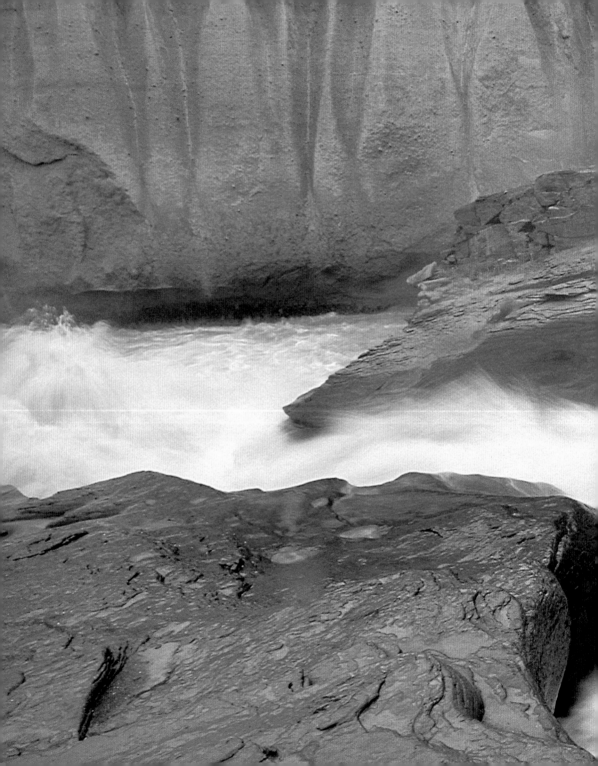

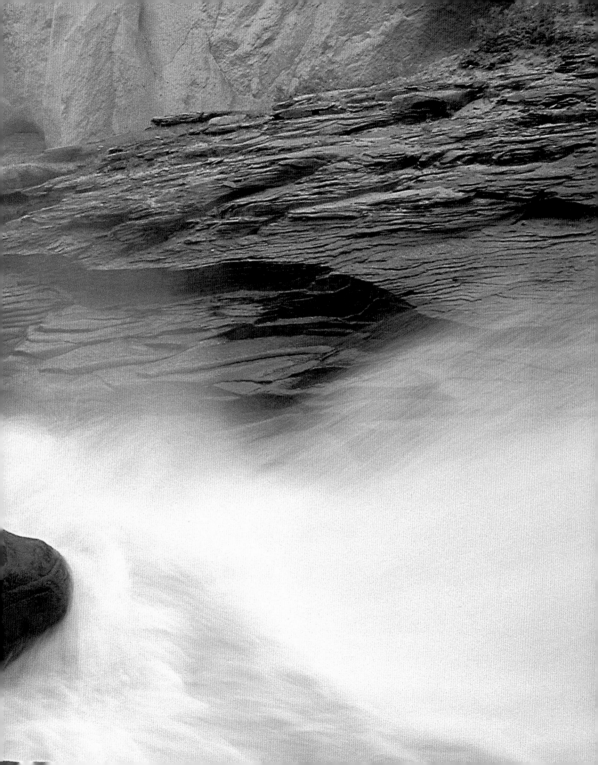

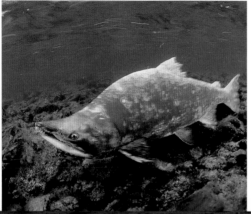

overleaf River Lethe, Valley of 10,000 Smokes, Katmai National Park and Preserve

left Spawning sockeye salmon (*Oncorhynchus nerka*), Wood-Tikchik State Park

below Brown bear (*Ursus arctos*) catching salmon, Brooks Falls, Katmai National Park and Preserve

right Kodiak brown bear (*Ursus arctos*), Kodiak Island

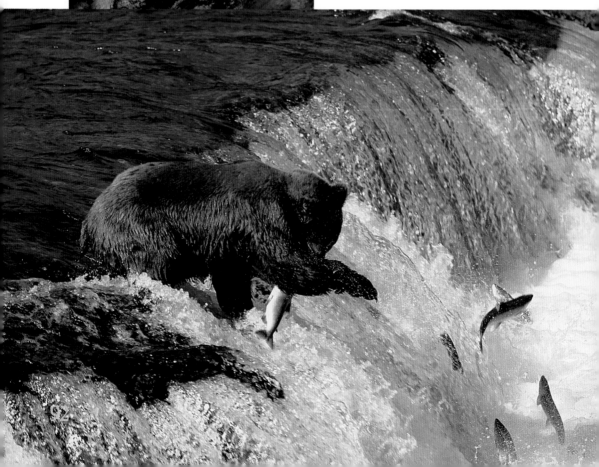

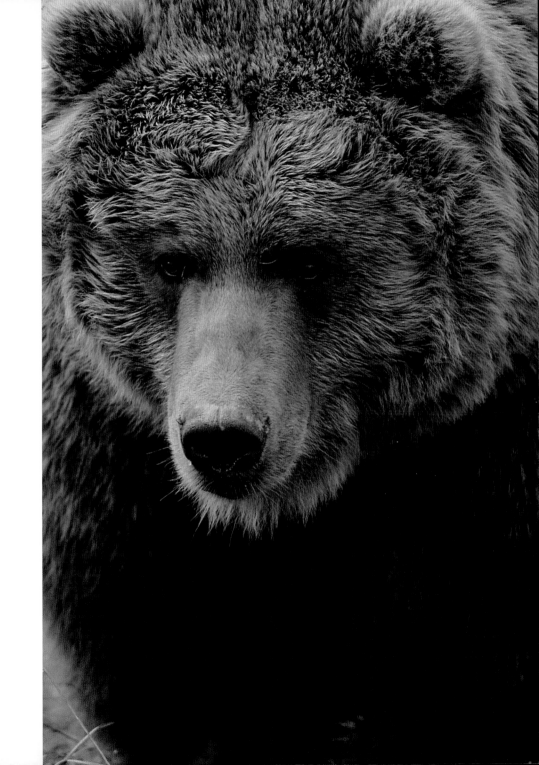

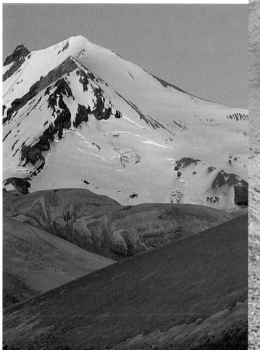

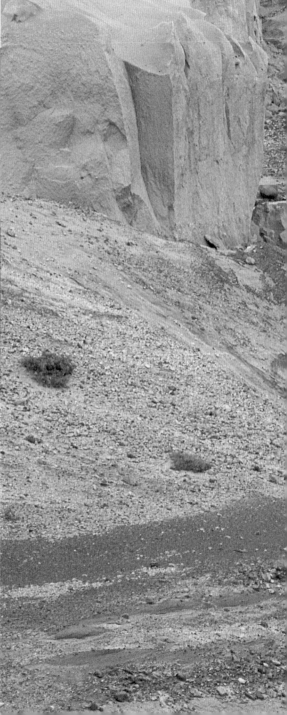

above Volcanic cone, Valley of 10,000
Smokes, Katmai National Park and
Preserve

right River Lethe, Valley of 10,000
Smokes, Katmai National Park and
Preserve

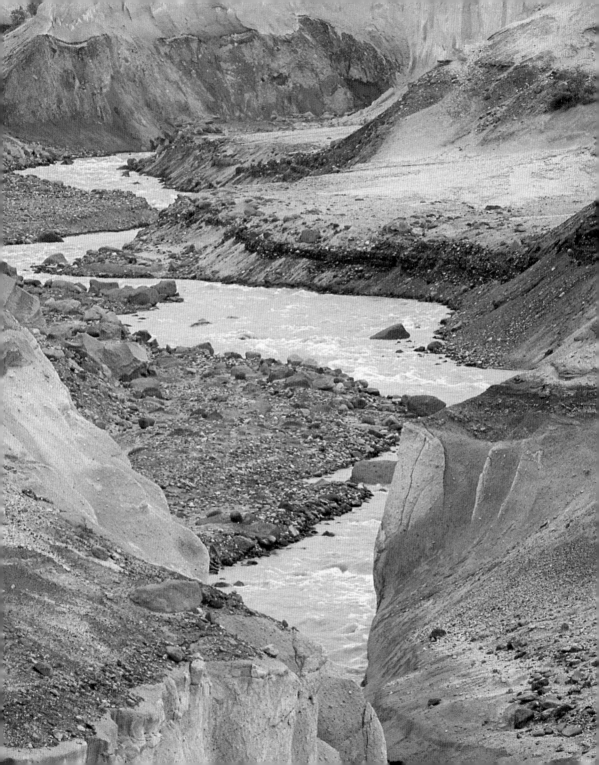

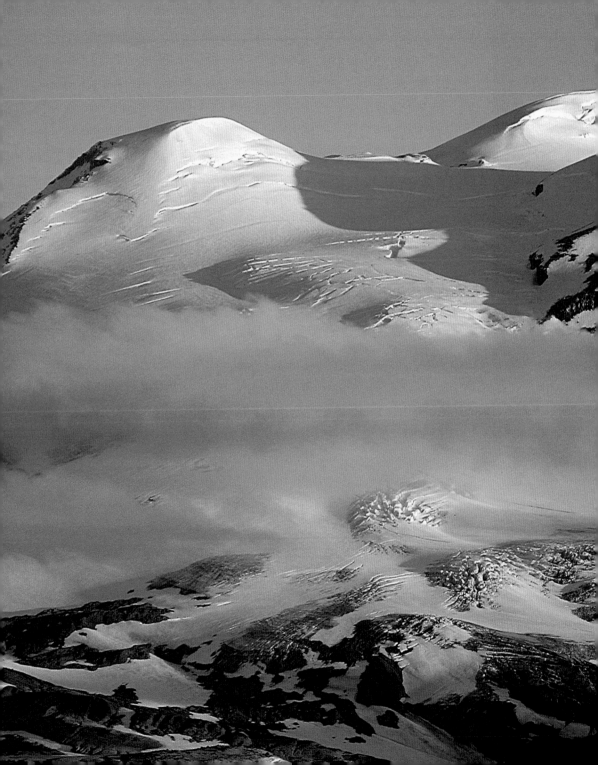

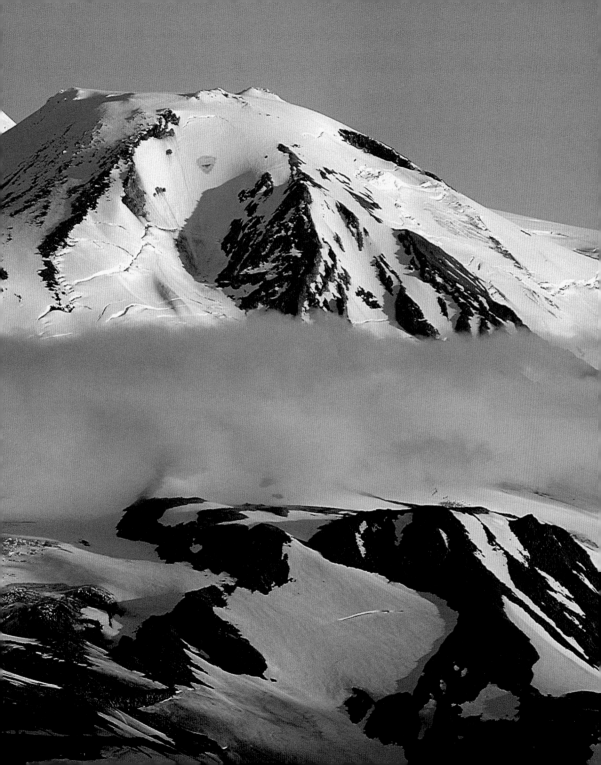

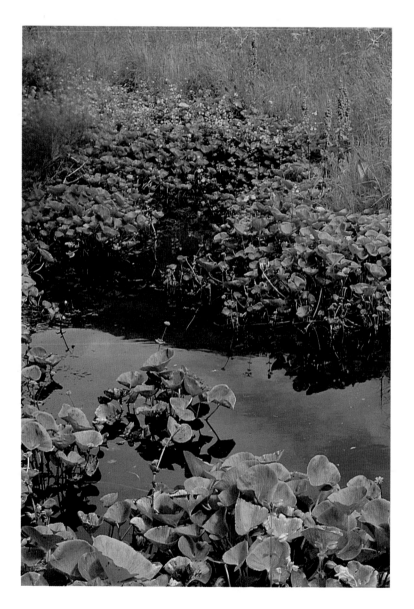

overleaf Mt. Mageik
volcano, Valley of
10,000 Smokes, Katmai
National Park and
Preserve

left Karluk Lake,
Kodiak National Wildlife
Refuge, Kodiak Island

right Red fox (*Vulpes
vulpes*), Togiak National
Wildlife Refuge

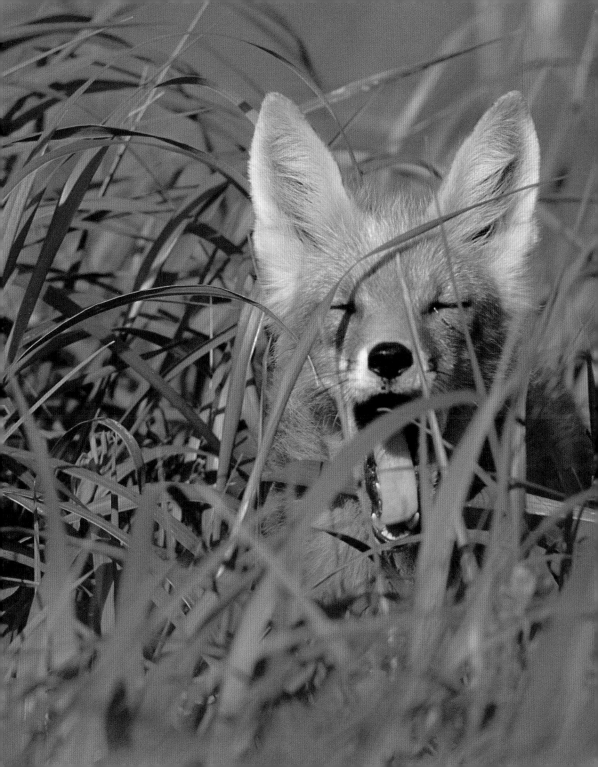

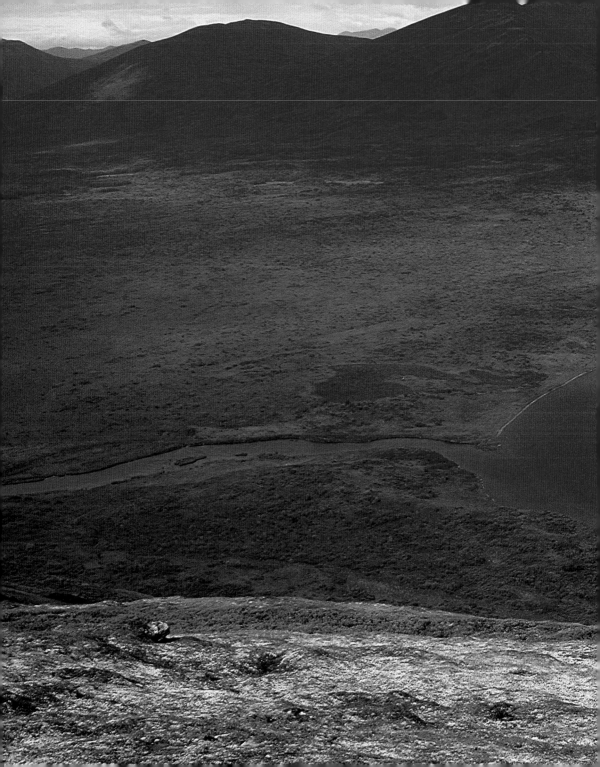

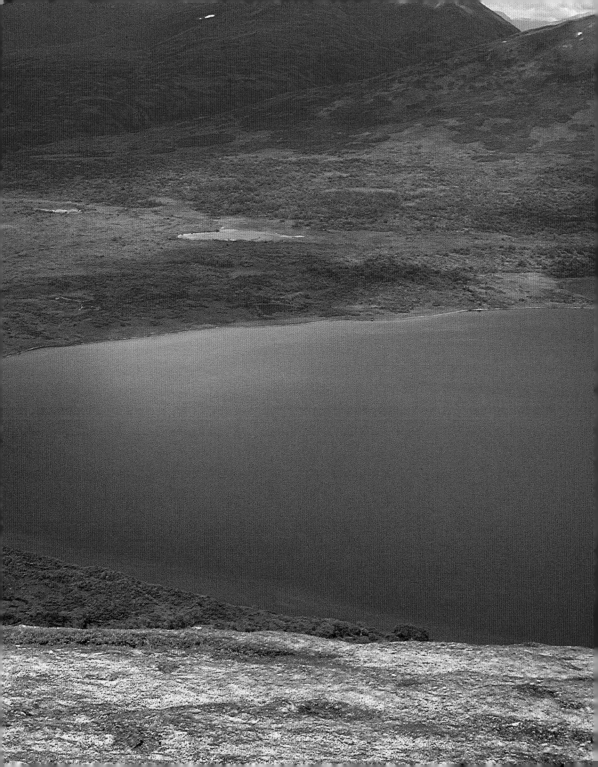

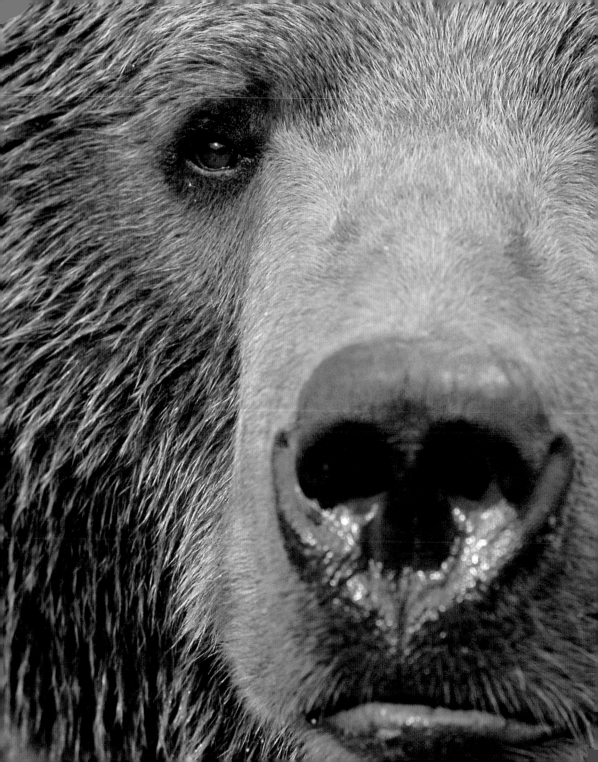

overleaf Karluk Lake, Kodiak National Wildlife Refuge, Kodiak Island

left Kodiak brown bear *(Ursus arctos)*, Kodiak Island

above River Lethe, Valley of 10,000 Smokes, Katmai National Park and Preserve

next page Iliamna Volcano viewed from Kachemak Bay, Kenai Peninsula

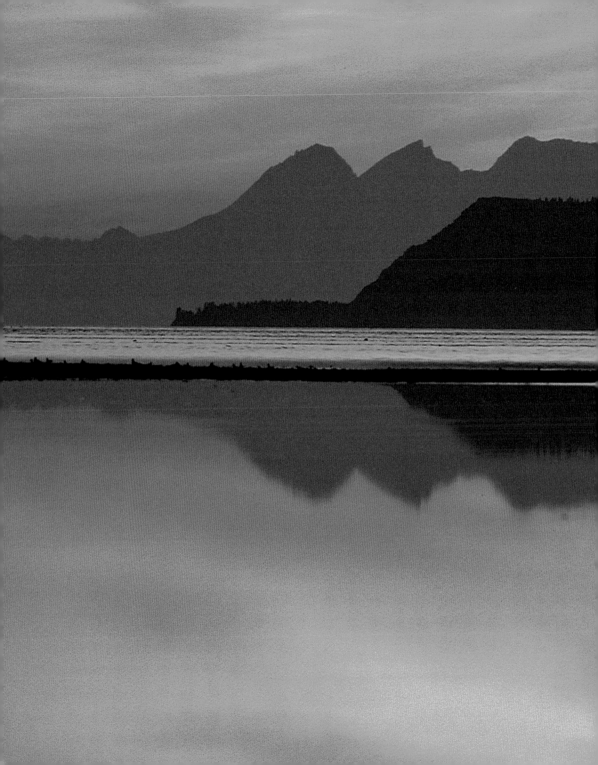

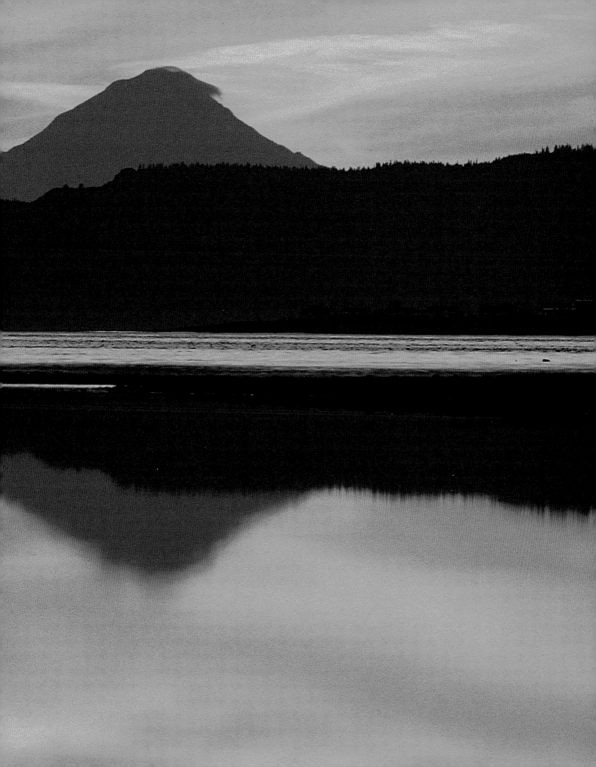

{ about the author }

Over the course of his 30-year career, Art Wolfe has worked on every continent and in hundreds of locations. His photographs are recognized throughout the world for their mastery of color, composition, and perspective. His unique approach to nature photography is based on his training in the arts and his love of the environment.

Wolfe has taken an estimated one million images in his lifetime and has released 57 books, including *The Living Wild*, which has sold more than 50,000 copies worldwide and garnered awards in *Applied Arts* and *Graphis*. His other books include *California, Alaska, Pacific Northwest*, and several children's books, such as *1, 2, 3 Moose* and *O is for Orca*.

Art Wolfe has been awarded the coveted Alfred Eisenstaedt Magazine Photography Award and has been named Outstanding Nature Photographer of the Year by the North American Nature Photography Association. The National Audubon Society recognized his work in support of the national wildlife refuge system with its first-ever Rachel Carson Award. Wolfe now spends nearly nine months a year traveling and shoots more than 2,000 rolls of film annually. He serves on the advisory boards for the Wildlife Conservation Society, Nature's Best Foundation, and the North American Nature Photographers Association, and frequently donates performances and work to dozens of environmental and educational groups.